BLUES

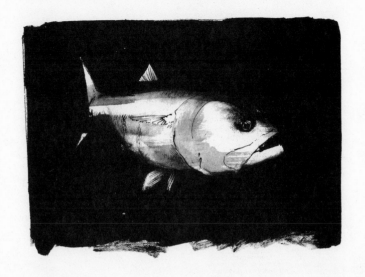

BLUES

John Hersey

WITH DRAWINGS BY JAMES BAKER

VINTAGE BOOKS

A DIVISION OF RANDOM HOUSE NEW YORK

FIRST VINTAGE BOOKS EDITION, May 1988

Copyright © 1987 by John Hersey
Illustrations copyright © 1987 by James Baker

All rights reserved under International and Pan-American
Copyright Conventions. Published in the United States
by Random House, Inc., New York, and simultaneously
in Canada by Random House of Canada Limited,
Toronto. Originally published, in hardcover,
by Alfred A. Knopf, Inc., in 1987.

Library of Congress Cataloging-in-Publication Data
Hersey, John, 1914–
 Blues.
 1. Fishing stories, American. 2. Bluefish—Fiction.
I. Title.
PS3515.E7715B58 1988 813'.52 87-45942
ISBN 0-394-75702-5 (pbk.)

A signed first edition of this book has been
privately printed by the Franklin Library.

Owing to limitations of space, permission to print
previously published material may be found on page 207.

Map by David Lindroth

Manufactured in the United States of America
10 9 8 7 6 5 4

Praise for

BLUES

"*Blues* is a special book, the kind you can picture coming upon in a beach house on a rainy August afternoon—its binding mildewed from the salt air, bits of sand caught up in the margins, its pages creased from frequent readings—he has never written a book of more delight."

—*Washington Post Book World*

"An enchanting book—larger even than its fascinating subject."

—Rod MacLeish, National Public Radio

"For Hersey, a fishing line is both for sounding the depths of the human imagination and for anchoring him to the limits of the sensual world. *Blues* aims for balance, it aims to teach and to delight, and it does both well." —*Cleveland Plain Dealer*

"Hersey's all-knowing Fisherman imparts generous wisdom about the sea, its vast teeming plankton and the great food chain it drives, as well as the environmental dangers that threaten it— and he does so in the eloquent prose that has made Hersey one of the most respected writers of his generation." —*Seattle Times*

"A celebration, a paean in honor of bluefish . . . beautifully written." —*The Atlantic*

"Hersey casts this lore with the grace of a smooth spinning reel."

—*Richmond News Leader*

To Sierra, Cannon, Eric, and . . .

ACKNOWLEDGMENTS

The Fisherman's acquaintance with the bluefish has been much enhanced over the years by trips in *Spray* to Woods Hole, with its many riches: the Woods Hole Marine Biological Laboratory, the Woods Hole Oceanographic Institution, and the Woods Hole Laboratory of the Northeast Fisheries Center of the National Oceanic and Atmospheric Administration. Particular thanks are due to John Boreman of the last of these three, for much patient help in the Fisherman's education; and to Bori Olla and Anne L. Studholme, who, having conducted many beautiful experiments on the bluefish at the Northeast Fisheries Center's Sandy Hook Laboratory, generously shared their knowledge. The Fisherman is grateful, too, for various aids to understanding from David G. Aubrey, John Gibbs, Paul R. Gross, Louis Leibovitz, John McDonald, Nancy Marcus, Edward C. Migdalski, John H. Steele, John Valois, and Stuart J. Wilk. And to Judith Jones, both for perceptive readings of *Blues* and for some knowledgeable hints on ways to make the bluefish delicious. And, of course, to the Stranger, for asking so many questions.

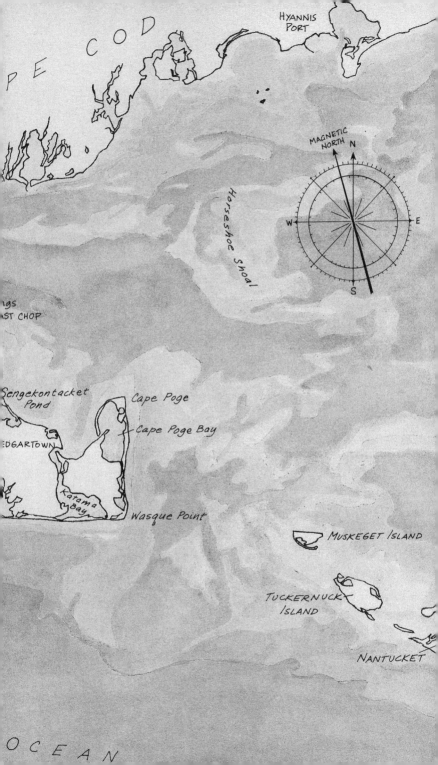

BLUES

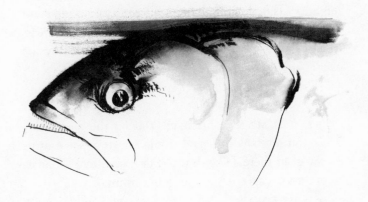

June 10

The fisherman swings his boat alongside the dock. He sees a familiar figure leaning on one of the pilings. This person has often been here in the afternoons, facing the sea but appearing to be somehow disconnected from it. He seems rooted to the shore like a tree. His face, however, is alert to the ferries, and he watches the sailboats leaning in their long tacks up to the harbor. He looks as if he may envy the sailors at their tillers. There is something deeper in his gaze, as well, which has interested the fisherman. It is as if the man is trying to puzzle something out. The fisherman has wondered what it

might be. Is he hoping that the sea will cast up some lost memory of his? Is he trying to catch sight of the years hiding in the waves? Or is he simply fascinated by the ever-changing blues of the water and the air? . . .

The fisherman decides to speak to him.

FISHERMAN: Stranger! You on the dock! May I toss you my bow line, and would you take some turns on the cleat there? Thank you. Stern line, too? Thanks.

STRANGER: Are you going fishing?

FISHERMAN: I am, yes. I've seen you here quite often, haven't I?

STRANGER: I come sometimes.

FISHERMAN: I've noticed you looking out at the water. Are you a sailor?

STRANGER: No, not at all. I have been completely land-bound all my life. I've lived in cities. I've walked to work on pavements. Here on this island my house is on William Street, in Vineyard Haven, right in the center of town. When I travel here, it's by air; I've never even ridden the ferry from Woods Hole.

F: Yet you come down to the dock often, and I've noticed your awareness of everything that happens in the bay.

S: I watch, yes, but I feel an ignoramus about all of it. As I say, I'm a thoroughgoing landsman. I go swimming from a beach, now and then, but I like to be able to put a foot down and touch the bottom—to know where the ground is. You say you've seen me here. I've seen you, too, you know, tying up once in a while. One of the things I have been keenly aware of is the intensity of anticipation on your face, when you're getting ready

to go out. I've seen you take off then in your boat, and watched you disappear eventually around West Chop. I've wondered what there was out there around the point that gave you that look of a votary. Quite without knowing it, you've made me realize what has drawn me to this dock all along: There seems to be an empty place in my psyche, where a feel for the sea should be, and I guess I've been wishing I could fill it.

F : Then you must by all means come out with me, and try to begin, at least, to do that. Won't you join me? I won't be out for long. You'll see some wonders, I promise.

S : I'd like to, very much. But I'm afraid I have a scruple. I hate the idea of slaughtering fish for sport.

F : I don't care for that idea, either. I fish for the table. Do you eat chicken?

S : Occasionally.

F : Someone has to wring the chickens' necks, you know.

S : I try not to think about that.

F : All I'm saying is that I am simply going out to get my supper. If you come, I'll invite you to share the meal with my wife and me. Fish that's just been caught is as sweet as corn right off the stalk. But there's more to going out there than just shopping for food.

S : What do you mean?

F : To begin with, if you come, I can almost promise you that we'll catch a bluefish. I've fished for blues out on Middle Ground for twenty years, and I have the honor of knowing them well. I've a good hunch where to look for them today. You will hold the rod and bring one in. I feel sure that in spite of your bias, that will be

an event in your life. Blues are magnificent animals. I tell you, I am very much in awe of the bluefish.

That's not all. Today, if you go, we'll troll along Middle Ground. That's a narrow underwater sandbank which reaches out slantwise into Vineyard Sound on the other side of West Chop from here. The Sound, you probably know, is the stretch of water between the north-west shore of Martha's Vineyard and the delicate archi-pelago across the way, the Elizabeth Islands. To run along the rip at the edge of Middle Ground in a small boat is an experience. The sights—and the conceptions—are breathtaking. You'll see. This June day shines. Every-thing out there is momentary. The waves constantly change their period and their curl and their texture as the currents and winds restlessly shift and wax or wane. And the light: The sky gives its blueness to the sea, the sea its greenness back to the sky, and both are written on by clouds. You'll hear a deep and complex drumming of time out there, as the engine ticks at nine hundred revolutions per minute through metronomic waves over the shoal formed by the glacier twenty thousand years ago. But above all I'm sure that you will come to feel, as I always do, a pepping up, a vivification, which I think comes from a sense of the mysteries of all the lives in the water—a sense of the teeming under the surface that a person has out on the "great and wide sea, wherein are things creeping innumerable, both small and great beasts."

Do you see the greenish cast of the sea today? It's becoming especially bright at this time of year. The vast meadows of plankton are blooming. Billions of dia-toms, single-celled plants, far too small for the naked

eye to perceive, droplets of greenish or golden jelly in exquisite glassy cases of many shapes—the basic food-stuff of all the creatures who live in or off the sea, including me and my family. When I scoop up a bucketful of water to wet down the fish I have caught, I pull up, in these spring days, an unseen vegetable market. Plants are not the only plankton—the word means "wanderers"—out there. There are also countless varieties of microscopic sea animals: radiolaria, for example, single-celled creatures with dazzling radiances of spikes all around them made of the same glassy substance that houses the diatoms; or foraminifera, which means "having windows"—for their tiny chalky red casings do indeed have many infinitesimal glass panes, as if to peep out through at a hostile universe. Then there are bacteria, and barely visible shrimplike creatures, and eggs and larvae of crabs and fish, and many kinds of jellyfish, which may run from microscopic to magnificently dangerous.

The tiny animals feed on the tiny plants, and what I think of as baitfish feed on the animal plankton. On Middle Ground the predominant bait throughout the summer are silversides, brilliant slender darts which at full maturity measure at most about three inches. The gluttonous bluefish that you pull in will have its belly crammed with silversides, or perhaps just now with squid, yet it will strike at the lure as ferociously as if it hadn't eaten for weeks.

You'll be aware of interconnections. The fish you catch will weigh about five pounds—the slim school out there just now is comprised of fish of that size. I am told it takes fifty pounds of silversides to produce a five-pound blue. It takes five hundred pounds of plankton

animals to produce those silversides. It takes five thousand pounds of microscopic sea plants to produce those plankton animals. The vast sea meadows, which give this northern sea great beauty in the spring, also give me and my family, indirectly, sustenance. "All flesh is grass."

The blues are not the only fishes along Middle Ground. During the season there will be—besides various forms of baitfish—striped bass, mackerel, weakfish, flounder, fluke, scup, tautog, bonito, sea robins, sand sharks, and many other species, several of which help feed my family. And above and on the water you'll see the birds that have taught me where to fish: graceful terns and raucous laughing gulls outnumbering the cormorants and herring gulls and black-backed gulls.

In my small boat running along the rip at Middle Ground you will have an idea of the chains of the forms of life, and I warn you that you may develop an ache in your chest, a symptom of mourning, over what mankind is doing to the deeps. We human beings cannot exist alone. We cannot live without the support of these other living things. There are rules of mortality and survival which we dare not break, else all living things up and down the links of interdependence perish. You spoke of slaughtering fish. We are killing the seas. Greed, ignorant plunder, rampant technology, profligate flux of sewage, mindless dumping of garbage and toxic chemicals, carelessness with the terminal instruments of war that man has finally invented—all these can strike, have begun already to strike, at the oceans' meadows of diatoms just as much as at large animals like the bluefish and the striped bass—and us. If these follies continue to go un-

checked they are liable to break forever, irreparably, the delicate laws of balance. And if that happens, links of life on earth—the fragile chain—will part and will never be able to be mended. We'd better marvel while we can.

s : I like the sound of everything you've said. You've touched on questions I've wondered about, standing here on the land these afternoons and looking out over the water. And I can tell, from what you say, that you'd probably open my eyes to lots of things that I've never even thought about. Yes, I'd like to join you, and I will.

f : Good. I think you'll be glad you did.

s : But I must remind you—forgive me if I step on your toes—I have to remind you of my real distaste for what I think of as the fishing mystique: all that notion of the elegance and nobility of a brutal blood sport.

f : Try to remember that we are going after food— that we are, in a way, exploring our place in the systems of life in the universe. I grant you that our place, when we think we've found it, isn't always comfortable. Sometimes it's awful, but often it's also awesome and very beautiful. It's what we have and must live with, at any rate.

s : I accept that. I'll try to accept the killing. Yes, I'll gladly come.

f : Just let me fill my water tank, and we'll be off. There. Cast off the lines and come aboard.

s : I like your boat. It seems bigger when you get in it than it looked from ashore. How long is it?

f : .Twenty-six feet. It's called a Sekonnet. It's old-fashioned, lapstraked, made of *wood*—to me that's the nicest thing about it. That connects it with a reach of

human restlessness from which steel and fiberglass are totally cut off: with Noah's floating zoo; and the brave *Argo* of the Golden Fleece, which had a piece of oak in its bow that could speak; ancient, batten-winged Chinese junks; Viking ships with their swan's-neck prows; the *Santa Maria*, fetching up on a strand of a world not really "new"; the *Victory*, the ship of the line on which Nelson died with duty on his lips; the surging tea clippers in the China trade; and the lovely J-boats, with lines like those of the swordfish, racing for The Cup. Not to mention all the sailing ships drifting through the great dreams of Homer, and of Melville and Conrad. This chunky thing is a so-called bass boat, built really for these waters. When the wind and current are running strongly in opposite directions out on Vineyard Sound, you get a nasty chop. I feel safe in this beamy wooden boat in the most threatening seas. Its high freeboard, giving it this deep cockpit, makes for a secure work platform for fishing on the wildest days. . . . But don't worry, we won't have rough water today.

s : I didn't notice the boat's name. I suppose you have it painted on the back.

f : On the transom. *Spray*. That was the name of the vessel Joshua Slocum sailed alone around the world—the first man to do that—at the end of the nineteenth century. Slocum liked to gam with big ships in the open sea—the two craft would luff up and crewmen would call greetings across to the solitary skipper—but then he liked even more to trim down and sail on all by himself. I often fish alone. I love my family and my friends, but from time to time I feel the value, now that the world is

so crowded, of solitude on the sea. I am seventy-two years old. I feel as if I've gone through life at full tilt. I've come to savor the serenity and privacy of an hour, here and there, of lonely thought. I do a lot of my work out here—the back-of-the-head sort of work you hardly know is being done for you by your considerate brain. . . . But I like company, too! I'm glad you're along.

s : How fast are we going?

f : About fifteen knots—a little more than seventeen miles an hour. When we troll, we'll just creep along at three or four knots.

s : Look at that white cylinder of a lighthouse! It's so stark, so like a Hopper, with that slant of the sun's whitewash wrapped part way around it.

f : That's the West Chop light, as I guess you know.

s : Lighthouses always make me sad. Why is that?

f : I wonder. Maybe because of the melancholy sound of the foghorns. You must have heard West Chop and Nobska Point, over by Woods Hole, moan at each other in the fog. Or maybe the sadness has to do with a mother-wit fear of the power of the sea. We all must have, deep down, a folk memory of shipwrecks. In the old days the Vineyard Sound shores of the Elizabeths— see them, over there, like backs of alligators?—used to be called the Graveyard, because of deceptive onsetting currents, on flooding tides, which so many sailors failed to understand. As recently as 1985, a skipper who thought he knew these waters wrecked a cruise ship, the *Pilgrim Belle*, at night, on Sow and Pigs reef off Cuttyhunk.

Here. This buoy marks the eastern end of Middle Ground. Red and black: that means that shipping can go either inside or outside the shoal.

Let me explain why we troll along Middle Ground. The crest of the shoal lies from six to ten feet below the surface, and on either side of it the water is from thirty to fifty feet deep. Currents run fairly briskly through here—a consequence of the rise and fall and eastward thrust of tides in narrow waters—and they pass over Middle Ground as if over a submerged dam. Bigger fish such as blues lurk, as alert as shortstops, along the lee side, waiting for baitfish to be swept over the barrier. The current is flooding now—coming in. Do you see that place, all along, where the water makes a smooth carpet ten yards or so wide, then breaks beyond into turbulence? That unsettled water is what we call the rip. I'll steer along on the smooth water, right over the shoal, and I'll let two lines out about forty yards, so the lures trail along in the rip.

As a whole, Middle Ground runs diagonally out into the Sound, right to the west, but the shoal isn't really straight. It takes a number of jogs, and at each jog there is a kind of sluice—we'd call it a hole—and those holes are the most likely places for blues to lurk.

I'll slow way down now, and if you'll take the wheel a minute, I'll rig the lines.

s : Where do we go?

f : Just steer for the tip of the last of the Elizabeths, that's Cuttyhunk, almost due west.

Today I'll use as lures these rubbery white things that look like squid, because that would be what blues are mostly feeding on just now. They're called Hoochies.

I'll hook a little sliver of pork rind on each hook, to let off a scent the fish may pick up and follow. Out they go. One rod goes in the rod holder on the port side. You hold the other. I've loosened the drag on the reel a bit and engaged the ratchet. If there's a strike, you'll both feel it and hear it.

s : Will I really know when one is on?

f : Will you ever! Blues strike like blacksmiths' hammers. In fact, what will occur to you first about these animals is that they are vicious; it will take time for you to see what truly beautiful mechanisms they are. Back in 1871, Professor Spencer Fullerton Baird, who became the first head of the now defunct U.S. Commission of Fish and Fisheries, rightly called the bluefish "an animated chopping machine." He described how a school of blues will rove like a pack of hungry wolves, destroying everything in sight, leaving a trail of fragments of their prey and a stain of blood and oil on the sea. Some fish masticate their food; blues chop and swallow big hunks. In 1965, a commercial fisherman, out at sea in pursuit of a fish called menhaden, which is used in the manufacture of fertilizer, told of having plowed through a thirty-mile-wide school of blues macerating hordes of menhaden. Feeding along coasts, blues have driven terrified menhaden up on beaches until they were piled a foot deep. Professor Baird estimated that in four summer months off the New England coast blues killed twelve hundred million million fish. That estimate may have been high, but there is no question that blues are both butchers and gluttons. They're cannibals that will eat their young. They will eat anything alive. They have stripped the toes from surfers in Florida. They make

the excesses of Huron feasts—at one of which, in 1635, a host served his guests twenty deer and four bears—seem, by comparison, genteel repasts. It's a myth, though, that blues will eat till full, like Romans, then vomit and eat again; that would be maladaptive. But they can't not eat; they can't suppress the urge to kill. If you paint sheep with lithium chloride, their predators soon learn it makes them sick, and they will no longer attack the sheep. But paint rabbits with poison and the hawk can't help itself, it will swoop and kill, even when sick from having eaten poisoned rabbits. The blue has the same dedication. "It is a hard thing to perswade the belly, because it hath no ears."

s : Doesn't sound much like a peaceable kingdom out here—the place for lonely, quiet thought you were talking about.

f : Oh, there's mayhem in the ocean, all right. There are sperm whales with huge stripes on their heads from battles with giant squid. Many of the blues I catch have scars on flanks and backs from having been attacked by their own brothers, and I've caught very young ones with open wounds that must just have been inflicted in their schoolyards.

s : If they're eating all the time, they must have remarkably efficient digestions.

f : Blues have strong digestive juices which can dissolve bones fairly rapidly. If a blue eats to satiation one day, it can feed the next day but won't eat as much as on the first day. By the second day after a full meal, it can take another full meal. It will, however, be motivated to kill within a short time of being stuffed. So it's better to talk about appetite than digestion; the bluefish

acts upon an everlasting hunger that it can't resist. Blues feed on the bottom and all up through the water column to the surface. Their digestion is most efficient when eating fish, or squid, or seaworms, less efficient with crustaceans. They get more energy quickly when the meat is on the outside than when it has an armor.

s : You said before that a fish with a full stomach would still strike at our lure. How can it eat when it's full?

f : It doesn't eat, it just chops. There's a fascinating wrinkle to that, which marine biologists have observed in captive blues in a thirty-two-thousand-gallon tank. When a blue is satiated on small prey, it will then be more tempted to strike at larger fish than at the same small bait—sometimes at fish not much smaller than itself. At that point the chopping seems pure murder.

But don't misunderstand me. All this about the hunger of blues doesn't mean they're always easy to catch. Blues don't swarm in big schools on the surface here often. And very big blues are mostly to be found in deeper waters off the south shore of the island. Meat fishermen—your bane, those who want to bring in as many pounds of bluefish as possible—consider my kind of fishing pretty puny. But what I like about fishing on Middle Ground is precisely that they're fairly scarce here most of the time. They're a challenge. You have to think like a fish to catch them.

s : Do blues think?

f : No one really knows. Animal behaviorists would say that they follow their drives—respond to stimuli. They certainly are capable of learning. They have memories. You're often going to hear me talking about blues

anthropomorphically, as if they were people. The way I did just now, talking about murder—applying human moral standards to our poor friends. Ideally I would like to talk the other way around—about you and me ichthyomorphically, as if we were fish. Indeed, after some time the true fisherman gets fishy himself. The trouble is, we don't have the language to converse like fish. Our understanding of fish talk—of whatever signals fish give each other—is deficient. It's one of our many ignorances. So I carelessly fall back on what we—

Wait! Fish on the line! Hand me your rod and take that one out of the holder. Now. Tighten the drag—the star beside the crank on the reel. Then a hard pull up on the rod to set the hook.

s : My God!

f : Yes, indeed. You have a life force out there on the end of the line. Keep it coming.

s : Damn. It's off.

f : No, it's swimming toward you. Keep reeling. . . . Now it's turned.

s : Oh, yes, it's on. How strong it is! Look at that leap!

f : Did you see it shaking its head?—No, no, no. Trying to deny that every deep dream must have an ending.

s : Look at that again! How long does this go on?

f : Not forever. Not till the end of time. Keep the line taut. . . . All right. When you get it in, work it alongside the boat. Drop the tip of the rod toward the water. Reel in till you see the leader. Look how wild it is at the last moment, as if it knows it's about to burst for all of eternity out of the mother fluid. Now! Lift it right

into the boat—we can do that with these small ones. Good work!

s : It's still fighting.

f : Yes. Look at the way it thrashes around. The denial—so stubborn.

s : What's that metal thing?

f : It's a disgorger, to reach in and get the hook of its fate out. I wear a thick rubber glove on my left hand, and use this instrument to keep my distance from those teeth. See the way the blue snaps at me? See it watching me? It can see almost as well out of the water as in. Those teeth can take a finger right off. An ichthyologist at Yale told me that his father, a chef, fishing one time off the Thimble Islands in Long Island Sound, lost part of a finger to a blue's choppers when he grew a bit careless getting a treble hook out.

s : That eye. It's so perfect, circle within circle, black within amber. But so ferocious!

f : Oh, yes—mesmerizing. And judgmental.

s : Judging me, as a murderer?—is there some reciprocal morality in fishdom? I'm surprised at my reaction to this. I've killed a fish, but I can't say I really feel guilty: You gave me the solace of the chicken necks. I feel tired; that was tense. I do feel sad. The sight of those desperate jumps was painful to me. But I have to be honest with you. I feel a twinge of triumph, too. My first fish—and to have it be so . . . so valorous, such a seawolf.

f : You did well, for the first time.

s : When I think about it, though, that sense of victory bothers me. I feel as if something atavistic, something disturbing that I never knew was in me, had come to the surface.

F : Fishing is complicated. That bluefisheye stare is corrective of your feelings, though, whatever they are, isn't it? It's a contradictory eye. I've always been glad I was looking into the eyes of these blues out here in the open air. Wouldn't you hate to have that eye glare at you under water, in the fish's own element? Robert Penn Warren had that experience once—not with a blue, but it was the same idea—and he wrote a poem about it. Swimming in the Mediterranean, he dived down deep, and he found himself face to face with a huge red mullet, and I remember that he wrote, "The mullet has looked me in the eye and forgiven nothing." It's a wonderful poem. I'll try to find it after supper and let you read it.

S : He's right. I could wish that this blue's eye weren't so unforgiving.

F : We'll go in, now, if you don't mind. I don't like to catch more than we can eat. I'll just take up a bucket of clean water out here, to keep the fillets in when we go ashore from the boat.

S : All in all, I enjoyed that, to my surprise.

F : I thought you would. I'll ask you out again, if you'd like.

S : I certainly would.

F : It's always so peaceful, coming back in. We've done our work. The sea has done its work in us. The bay welcomes us. See how East Chop glows in this light.

S : But that thumping in the box. Isn't that death coming on?

F : Yes. I told you, fishing is complicated. It dies for our living. . . .

Now that we're on the mooring, our fish's struggle is over—it has made the sacrifice of a link in the chain. Do you see how that shimmering steely blue-green color that it had at first has faded, gone flat? It's as if a fish's soul had pigment. I remember reading once about Seneca's outrage as he described a Roman banquet in Nero's time at which, between courses, a mullet was passed around swimming in a globe of glass, so that the guests could watch its exquisite reds, yellows, and blues go dull as it died—to whet their appetites with the drama of the pallor of death.

s : How barbaric—and those diners thought they were the most highly civilized people in the world, didn't they?

f : Look, I'll show you my way of filleting a blue. The whole secret is a sharp knife. First, I scale both sides with the back of the knife, working against the grain, so to speak, from tail to head. Next I hold the body perpendicular to the cleaning board and make two shallow lengthwise cuts along either side of the dorsal fins, from head to tail. Then the body goes flat, and I make a slanting cut across it, just aft of the gill covers and the pectoral fin, cutting in till the knife hits the spine, and then another transverse cut just forward of the tail. Now I slip the knife into the upper of the two shallow lengthwise cuts and carefully work the blade along the spine the whole length of the fish, from head to tail. Then the blade goes in parallel to the spine to strip the rest down off the ribs and along to the tail, so the whole fillet lifts right off. I wash it in the Sound water and put it in my small shore pail. The same operation on the other side,

and we're all done; we've taken off almost all that's edible—without having had to gut the fish. The professional fishermen cut fillets with just one slash of the knife from one end of the fish to the other, but I get a lot more of the meat this more careful way. Now the carcass goes overboard to feed the life at the bottom of the harbor. . . .

Just let me put the fish bucket in the dinghy. You sit in the stern. I'll row. . . .

[*At the house*:] May I introduce you to my wife, Barbara? Barbara, I took this gentleman fishing this afternoon and promised him supper if he caught a fish.

s [*to Barbara*]: What an afternoon we've had!

F : Come in the kitchen while I cook our fish. Barbara and I have worked it out that it's appropriate for the one who catches the fish to cook it.

First, I'll skin the fillet. Some people think bluefish tastes oily. Skinning is a boon, because most of the oiliness is in the skin. I put the fillet on a cutting board, skin side down. The trick is to make a little cut here near the tip of the narrow end of the fillet, to give your left hand a fingerhold. This enables you to keep the fillet from sliding as you then insert the knife to the right of the fingerhold and work the blade along just above the skin. Like that.

Tonight I'm going to cook our catch in the simplest, purest way. First, I turn the broiler on. Melt a half stick of butter on the stove top and stir in the juice of one lemon. Spread a little of this on the bottom of a broiling pan; put the fillets in the pan, former skin side down; spread lemon butter on the meat; and put it under the broiler about five inches away from the flame. . . . Baste

with more of the lemon butter every three or four minutes.

s : How do you know how long to cook it?

F : A wonderfully reliable rule has come down to us from Canada: Measure the fish at the thickest part, and then cook ten minutes to the inch. It's amazing: This works pretty well with all kinds of fish and no matter how you're cooking, whether broiling, baking, poaching, frying, grilling, whatever. The great crime of fish cookery, almost universally perpetrated by even the best restaurants, is overcooking, so to be safe I cook a little less than the ten-minute rule would dictate and test with a fork. If the fork goes straight through without resistance, it's done; if it hits rubber, cook a bit longer. But get it out the instant the flesh is soft all the way through. . . . To table. Salt and pepper to taste.

s : It's delicious!

F : And all the sweeter because you caught it.

BLUES

THE RED MULLET

by Robert Penn Warren

The fig flames inward on the bough, and I,
Deep where the great mullet, red, lounges in
Black shadow of the shoal, have come. Where no light may

Come, he, the great one, like flame, burns, and I
Have met him, eye to eye, the lower jaw horn,
Outthrust, arched down at the corners, merciless as

Genghis, motionless and mogul, and the eye of
The mullet is round, bulging, ringed like a target
In gold, vision is armor, he sees and does not

Forgive. The mullet has looked me in the eye, and forgiven
Nothing. At night I fear suffocation, is there
Enough air in the world for us all, therefore I

Swim much, dive deep to develop my lung-case, I am
Familiar with the agony of will in the deep place. Blood
Thickens as oxygen fails. Oh, mullet, thy flame

Burns in the shadow of the black shoal.

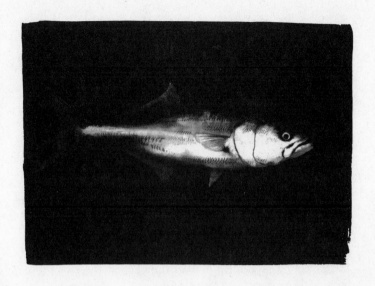

June 20

FISHERMAN: Perfect conditions today. South-west wind and a "smoky" sky. We'll be out there for the last two hours of the ebb tide.

> Wind northeast,
> Fish bite least,
> Wind southwest,
> Fish bite best.

That's true for these waters, anyway.

STRANGER: You said last time it's peaceful coming back in. It's exciting going out.

F : Does your saying that mean that you're so quickly reconciled to the idea of killing fish, at least for food?

s : No. That wasn't what I had in mind. I was thinking of how serene it is out on the water, cut away from the world. But I also have to admit that the experience of catching that bluefish the other day has hung on in my mind, like the half-memory of a vivid dream, with its vague residue of both pleasure and disturbance.

F : That was a vivid fish you caught.

s : It certainly was—and it tasted good, too. Yet I still feel troubled. . . . Tell me: Why is it always rough off the point here?

F : I suppose the reason they called the two promontories East Chop and West Chop was that there's almost always choppy water off each of them. (Or maybe they called them chops because they're the jaws of the harbor.) The troubled water, anyway, is a result of a conversation that's always going on, off these points, between wind and current. The influences quarrel. Sometimes they get as contentious out here as Capulets and Montagues, or managers and umpires—threatening to kill. The Scots call these disturbances "roosts"; they have given some of the cruelest of them mythic names—the Bore of Duncansby and the Merry Men of Mey at Pentland Firth—and there are such fierce ones off the Shetlands that "in this confused, tumbling, and bursting sea," the *British Islands Pilot* says, "vessels often become entirely unmanageable and sometimes founder." On wild days here, east wind, westerly current, I've learned by bitter experience to skirt the turbulence. We can bounce through it easily today.

s : Am I right that we're getting farther out on Middle Ground today than last time?

F : Yes, on an ebbing current the blues often move out to the west. Then they'll work along the shoal against the current, so that at slack water, at dead low tide, they'll be back up at this end.

s : You said the other day that it would take me a while to see—I forget your exact words—what "beautiful machines" the blues are?

F : Mechanisms. It was Dr. Baird who called them machines—"animated chopping machines."

s : What do I look for?

F : I'll tell you. But first let me get the lines out. Silversides have begun to show up as bait, so I'll use these ounce-and-a-half blue Rebels for lures today.

s : Is that what silversides look like?

F : No, these are much bigger. They're painted up to look like little herring—or baby bluefish, for that matter—more for human eyes than blues' eyes, I'd say. What matters to the fish is a lifelike swimming movement of the lure in the water, not its cosmetic get-up. Do you remember I told you that when a blue is crammed full of small fry, it will hit larger fish? That's why the Rebel so often works.

Now. The beauty parts of blues. I guess we have to start at the beginning: The nations of fishes are far more numerous and various than the nations of man. And far more diversely and garishly embellished and fancified. Who among us would dare to go to the office dressed up like a blue and green and rose and silver-dotted and red-finned opah? The bluefish is not so brilliantly marked as that; it has other distinguishing gifts, though. There are

about twenty thousand different species of living fishes in the seas—nearly twice as many as there are kinds of birds, and five times as many as there are mammals. To know which fish you're talking about, you have to have noticed a whole series of progressively complex differentiating traits. Blues belong, first of all, to the class of teleost fishes: bony fishes, as opposed to others whose armatures are entirely of cartilage—sharks, rays, skates, mantas, chimaeras, and such; these have no skeletal bones at all. Next, blues belong to the very large acanthopterygian superorder, defined by such things as that its head bone is connected to its pectoral bone; its gill opening is in front of its pectoral fin; it lacks a duct to its air bladder; and so on. Next, blues belong to the order of Perciformes, or perchlike fishes, defined, again, by their common arrangement and placement of fins, and other shared physical characteristics; the order includes perches, sea basses, pompanos, dolphins, porgies, and many other fish families. And, finally, it happens to be the only member of its own family within the order, and it was given the Latin name *Pomatomus saltatrix* by the great taxonomist Linnaeus. When we catch one, I'll show you why that name.

Speaking of names, blues are called different things in different places. Around here, when they're babies they're called snappers, and when they're about a year old some people call them tailors. Vineyarders call three- to five-pounders rats. Elsewhere the bluefish is called chopper, greenfish, snap mackerel, horse mackerel, skip mackerel, and skipjack—there are also other fishes called skipjack tuna and skipjack herring, which get their names from their habit of seeming to skim on the sur-

face as they chase smaller fish, as blues sometimes do. In Africa the blue is called elf, shad, fatback, and anchoa, and by various African names, of course; all sizes are called tailor in Australia. The name tailor may have come from the fact that with their sharp teeth and powerful jaws they can cut their way out of fishermen's nets.

s : You said "elsewhere"—Africa, Australia. Are they in all the oceans?

f : No, their distribution is spotty. They appear at different times of year on our east coast, from Nova Scotia to Texas. They're caught off Cuba, Venezuela, and from Brazil down to Uruguay; off the Azores; from Senegal and Angola to South Africa; in the Mediterranean and Black seas; off the eastern coast of southern Africa and around Madagascar; off the Malay Peninsula and Tasmania; and along southern and western Australia. But never in most other places; never off the coast of northern Europe, never off the whole west coast of North and South America.

s : Why not?

f : No one knows. And think about this, Stranger. We know a bit about the life in the sea, but very little, really. There are great mysteries in the oceans. I don't need to tell you that knowledge has exploded in this century. We know an astonishing amount about the structure of the atom. We've made it our business to find out a great deal about the atom because we think we may have some uses for the fire in its heart—in its nucleus, where an expectancy of great power constantly vibrates. We have isolated its electrons, its protons, photons, neutrons, quarks, "strong force," "weak force." Astonishing

knowledge. We have taken understanding of many "practical" matters, as we think of them, very far. We're spending billions on research about the heavens, for good and for ill. But our knowledge of our fellow creatures in the watery two-thirds of our earth's surface: rudimentary, crude, maybe dangerously limited. It's time we—

s : Hold it! There's a fish on my line!

f : Steady. . . . Easy. . . . That's good. Say, you learn fast.

Let me just get the hook out. Now. Look here, while I hold this toothy thing down with my rubber glove. *Pomatomus saltatrix.* The first word is new Latin from two Greek words: *poma*, "cover," and *tomos*, "cut." Do you see this prominent dark line on the gill cover that looks like a scar? That must have been the feature that struck Mr. Linnaeus's eye in 1754, when he was naming our friend. The other word—well, you've just seen the explanation for it. *Saltatrix* means "leaper," "jumper." The salt in that word isn't sea salt; it's somersault salt.

s : It *was* a jumper! . . . You may be surprised by my asking this, but do we have to go in now? Can't we try to catch another?

f : I think their hook is in *you*, Stranger. We're fishing for food, you remember. Are you so hungry?

s : You're right to ask. I'm surprised at myself.

f : Don't worry. I understand what you're going through. Fishing, as I said the other day, is complicated. Yes, we can catch one or two more, and give them back to the sea. I'd like, though, to put on lures with the barbs filed off the hooks, so the fish will be less apt to be wounded, if we catch any more. . . . Let out your line. We'll run back over the hole where we caught that one.

s : I like it that you're chary about the number of fish you take ashore. I gather that striped bass are a threatened species. Are you worried because bluefish are in the same trouble?

f : No. Right now they're thriving. I just hate hearing sport fishermen boast: "We caught thirty-four blues in two hours." In the fishing derbies around here a few years ago, before they started distributing extra fish to the elderly, contestants used to take scads of big fish—lunkers, ten-, twelve-pounders—to the dump each evening. Imagine it. My objection doesn't stem from compassion for bluefish. Why should I have it when they have none for each other? It's that I hate to see the world's food supplies willfully wasted and mismanaged. I think of the recent famine in Ethiopia. When I was a child—starving Armenians. Hungry Americans today, for that matter, with an administration in Washington that seems to think that their only problem is that they're ignorant or lazy. I have so far three selfish reasons for caring about the proteins of the future; the reasons are named Sierra, Cannon, and Eric: my grandchildren.

s : You said blues are thriving "right now." What did you mean by that?

f : Bluefish come and go in a way no one understands—another of the mysteries. They were plentiful off the New England coast in colonial times, but then from about 1764 they totally disappeared and didn't show up again until about 1810. There were tremendous catches from 1880 to about 1905, when they dropped off again for several years. There was a sharp decline again in the forties; in 1941 almost none were caught except for a few off Maryland and Virginia. I had a rotten

year out here three years ago; last year was wonderful. A strange thing is that the abundance cycles of bluefish are reciprocal to those of striped bass; when one species is up, the other's down. Stripers really are terminally threatened now, though. The difference is—

s : Fish on! Fish on my line! . . .

f : Good work.

s : This one's bigger than the other. Can't we keep this one and throw back the first one?

f : The other one wouldn't survive. It's alive in the fish box, but it has been out of the sea too long.

s : Will this one live? Does your getting even an unbarbed hook out hurt it?

f : It probably doesn't make sense to talk about pain in a fish—anthropomorphic thinking again. If it means anything to a fish, it means a signal for safety. Fish have intense responses tied to survival. If a fish is wounded, the trauma will heighten its antipredator response, but this won't affect its response to food. There's an account of a Greenland shark—*Somniosus microcephalus,* used to be caught for its liver oil—allowing itself to be stabbed repeatedly in the head while feeding on a dead whale, going right on eating. As to the memory of pain, an angler who had caught a perch told of finding himself unable to remove the hook without taking one of the fish's eyes out of its socket with it; he threw the fish back, baited his hook with the eye, and a few minutes later caught a one-eyed fish—the very same one.

s : What gruesome stories!

f : I told you, fishing is complicated.

s : But you think this one will live?

f : I do. There's a famous poem by Elizabeth Bishop, in which she tells about catching a huge veteran of a fish which has five old fishhooks "grown firmly in his mouth"—it has survived five times to fight again. I'll look for the poem tonight. I try to be careful in the way I handle a fish that's going back in the sea. These blues are tough fish. This one will live.

s : I'm glad.

f : I guess we'd better head in—the current's dying out, nearly slack water, no more rip. By the way, how big would you say your fish was that we threw back?

s : About this big.

f : Speaking of the "strong force" and the "weak force," did you ever notice the mysterious force of nature that pushes people's hands apart when they're trying to tell how big the fish was that got away? I'm not accusing you—you did pretty well. Of course you'll have to make allowance for some growth in the next few tellings. A Maine fishing guide once said, "The only difference between a hunter and a fisherman is that the fisherman expects to be branded a liar and therefore exercises some control over his imagination." Not always, apparently. The National Marine Fisheries Service was forced to conclude that all of the surveys it had conducted up until 1979 of the number and sizes of blues caught by sportsmen, depending as they did on the word of the fishermen themselves, were nearly *a hundred percent* inflated. There was a splendid philosopher and teller of tall tales here on the Vineyard, Joseph Chase Allen, he's dead now, who swore that as a boy he'd heard a ninety-

year-old man named Heroditus Vincent tell about catching blues of more than a hundred pounds. If people doubted him, Joe Allen said, Heroditus would show them the dried skull of a blue which he used to pull off the shelf on Halloween and wear over his head like a combination cap and mask to spook the kids with. Then there was the famous Emperor's Pike, caught in a lake in Württemberg in 1497, with a copper ring through the gill cover saying the fish had been put in the lake by Frederick II in 1230. It was supposed to be nineteen feet long, and to weigh five hundred fifty pounds. An oil painting of it was said to hang in the castle of Lautern in Swabia, and its actual skeleton was preserved in the cathedral at Mannheim. Nineteenth-century scholars found some flaws in the accounts, though, maybe the wrong Frederick, wrong date. A distinguished German anatomist finally examined the skeleton and found that it had many more vertebrae than a pike could possibly have—the skeleton had been lengthened to validate the story!

s : How big *do* blues get to be?

f : Eighteen- or nineteen-pounders win the Vineyard derbies. The record blue caught in America by rod and reel weighed thirty-one pounds and twelve ounces, taken one night in 1972 off a pier at Cape Hatteras. Most blues that anglers catch weigh from three to five pounds. Off Australia blues are said to grow regularly to four and a half feet and to twenty-five pounds. As to that, there may be a little Australian enthusiasm worked in there somewhere. Unlike birds and most mammals, fish continue to grow after they've reached sexual matur-

ity. This gives them a fantastic geriatric advantage. The older and larger a fish grows, the faster it can swim, so it can devour the younger of its kind. Aging birds and most animals have to face being shoved aside by more vigorous youngsters. I've come to a time of life when I envy old blues. Bluefish start to spawn at age two, when they're about fourteen inches long. If the Aussies aren't just jawing, blues grow to fifty-four inches down under. Now, if a human being continued to grow at a comparable rate, he'd get to be more than twenty feet tall and weigh half a ton. Would the Chicago Bears be interested?

s: Would you like me to pick up the mooring?

f: Thank you.

s: But I thank *you*. These days on the water have meant a lot to me. I think back to the afternoons when I used to stand on the dock looking out and just guessing about the various kinds of life in the sea. These have been marvelous trips.

f: Here, I'll show you something to marvel at. Before I sliver [*pronounced with a long "i"*] your fish—that's an old New England term for filleting—I'd like you to look at this: Do you see this delicate line that runs the whole length of the fish from its shoulder and along its flank to its tail? It's called the lateral line, and it's something that seems almost unbelievable to me. It's a composite sensory organ. It gives the fish a sixth sense, rather like a cross between hearing and touch. What you see on the surface, if you look closely, is a series of pores through the scales, giving access to a long channel underneath, in the skin. Within the channel, which is filled with mucus, there's a row of many clusters of tiny hair-

like antennae, which send continuous messages along nerve fibers to the brain. There are, besides, similar channels on the head and face of the fish, not so easy to see.

s : What are they for?

F : You may well ask. Ichthyologists have been asking themselves that question for a long time. The lateral line remains an implacable mystery; human beings can only guess at its use. Marine biologists know the physiology, from dissection and observation; they can say, for example, that the sensory buds of the lateral line connect with the vagus, or tenth, cranial nerve. Marine behaviorists know from experiments that lateral lines are sensitive to vibrations in the water of extremely low frequency, about six per second, and even slower. Thus the lines are delicately responsive to tiny changes in the movement of the water around them. So the guesses are several. That the lateral lines let the fish know about the approach of predators, even from the rear, where its eyes can't pick up the threat. Or about its own approach to prey, or to obstacles in the water—you may have noticed that fishes in an aquarium don't bump against the glass, unless they want to. Maybe the lines help the fish in orientation. Tell it about its relation to colleagues in schooling, and let it take advantage of motions within the school to save energy, as birds flying in a V take advantage of the turbulences set up by the wing flaps of their friends. Perhaps serve as a speedometer. Perhaps help the fish to "see" in the dark. It is possible that swift messages imparted to a community of lateral lines help to cause the instantaneous shattering of a large school when a predator approaches one part of it. These gadgets are a wonder. They are unique; there are no solid ana-

logues to them in the outside world. The sonar system that enables flying bats to judge their distance from objects in the dark differs from the lateral line in that the bats have to issue outgoing messages—squeaks which are echoed—in order to make it work. Human beings invented the so-called degaussing girdle, the electrified belt certain ships wore in the Second World War to demagnetize them and protect them from magnetic mines. But sonar and degaussing are crude by comparison with the lateral line; they are devices with a single function. The lateral is so much more versatile and sophisticated—so much higher tech.

s : I've certainly never noticed those lines on a fish before.

f : Almost all fishes have them. . . .

All right, we're ready to go in. . . .

[*In the kitchen*:] Tonight I'm going to cook the fillets by the second most basic method, and a good one it is. I skin the fish. Now I'll make some mayonnaise in the blender—though I must admit I often just use boughten mayonnaise; but then, you're a guest. I put some butter and chopped chives in the broiling pan and put the pan under the broiler to melt the butter and let it soak up the chive flavor—but not too long, careful, it gets black. Meanwhile I coat the meat side of the fillets with a generous slavering of the mayonnaise. Under the broiler, five inches from the flame. While the fillets are cooking, I'll use a pair of scissors to cut up fine some frond ends of dill. . . . Ten-minute rule. . . . Scatter the dill fairly generously over the fillets. . . . *Le diner est servi!* . . .

s : Oh my!

F : Yes, it's good, isn't it? The mayonnaise keeps the moisture in. Of all the ways to cook blues, Barbara likes this one best.

S : Why couldn't we have kept the second fish we caught and put it in the freezer?

F : We could. But when we ate it, it wouldn't have tasted anywhere nearly as good as this fresh-caught one. Bluefish is savory but it doesn't keep well. It should be eaten within one or two days of capture, or, far better, within two or three hours. . . . By the way, show Barbara how big the one was that we threw back.

S : This big.

F : Hm. One problem about bringing fish in to freeze them is that they may shrink on the way ashore.

THE FISH

by Elizabeth Bishop

I caught a tremendous fish
and held him beside the boat
half out of water, with my hook
fast in a corner of his mouth.
He didn't fight.
He hadn't fought at all.
He hung a grunting weight,
battered and venerable
and homely. Here and there
his brown skin hung in strips
like ancient wallpaper,
and its pattern of darker brown was like wallpaper:
shapes like full-blown roses
stained and lost through age.
He was speckled with barnacles,
fine rosettes of lime,
and infested
with tiny white sea-lice,
and underneath two or three
rags of green weed hung down.
While his gills were breathing in
the terrible oxygen
—the frightening gills,
fresh and crisp with blood,
that can cut so badly—
I thought of the coarse white flesh
packed in like feathers,
the big bones and the little bones,
the dramatic reds and blacks

of his shiny entrails,
and the pink swim-bladder
like a big peony.
I looked into his eyes
which were far larger than mine
but shallower, and yellowed,
the irises backed and packed
with tarnished tinfoil
seen through the lenses
of old scratched isinglass.
They shifted a little, but not
to return my stare.
—It was more like the tipping
of an object toward the light.
I admired his sullen face,
the mechanism of his jaw,
and then I saw
that from his lower lip
—if you could call it a lip—
grim, wet, and weaponlike,
hung five old pieces of fish-line,
or four and a wire leader
with the swivel still attached,
with all their five big hooks
grown firmly in his mouth.
A green line, frayed at the end
where he broke it, two heavier lines,
and a fine black thread
still crimped from the strain and snap
when it broke and he got away.
Like medals with their ribbons
frayed and wavering,
a five-haired beard of wisdom
trailing from his aching jaw.

I stared and stared and victory filled up
the little rented boat,
from the pool of the bilge
where oil had spread a rainbow
around the rusted engine
to the bailer rusted orange,
the sun-cracked thwarts,
the oarlocks on their strings,
the gunnels—until everything
was rainbow, rainbow, rainbow!
And I let the fish go.

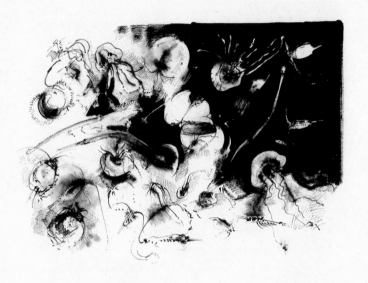

June 24

FISHERMAN: On a day like this, with no wind and such a calm sea, I'm taking you out at dead low tide, slack water. When the current begins to run this afternoon there won't be any rip on Middle Ground, just a kind of boiling up, like that in a sluggish river with a rough bottom; you need a breeze for a rip. So we'll cast for the fish in deeper water alongside the West Chop end of the shoal. The first hour of the flood tide is a good time for blues.

STRANGER: It goes without saying that I've never tried casting.

F : I'll show you how. We'll have a little practice.

S : What a day! Every day is different from all the other days out here, isn't it?

F : Every minute is different—has a different light —from every other. It's as if every minute were a sequin on a dress on a walking woman.

S : Even without the fishing—

F : Now, now! We're out to get our supper. With this clear sky, it's a bit bright today. The fish will be lying deep in the water, waiting to dine at dusk, and a little choosy. Hard to tempt. We'll see. We'll use this metal jig; I'll put a small flag of pork rind on the hook. All right, here you go.

[*Instructions on casting, off West Chop.*]

F : There, that's better. Remember, snap it, like a fly swatter. Don't forget to let the jig sink for several seconds when it hits the water; the fish are deep. Fire away.

S [*casting*]: I can't get over how beautiful it all is. This iridescent surface. I see the greenish tint you were talking about that first day.

F : Yes, the meadows of plankton. May I tell you about one of the most exciting days of my life?

S : How big was the fish you caught that day? Was it so big that it almost pulled you overboard?

F : The day I'm speaking of had nothing to do— directly—with blues. Indirectly, yes. Ah! I'm afraid your asking me those questions, with a little edge I think I heard on your voice, means that you didn't like my teasing you about the size of the fish we threw back last time. I apologize.

S : Thank you, there's no need. I just thought that

in case you were going to tell me a fish story, I should hold you to a landsman's standard of truth.

F : But you're getting to be a fisherman, sir! You must remember that there's plenty of salt in the sea to take with the tales your fellow fishermen tell.

The day I'm thinking about was very much like this one—a dazzling high sky and not a breath of air. A watered-silk sea. The Elizabeths, Woods Hole, Falmouth, you could almost touch them, the air was so clear. I took *Spray* to the Middle Ground hole right opposite Leroy Goff's house—that squarish shingled house standing alone near the water off there—

S : I see the one you mean.

F : That's the hole where I've caught more blues than anywhere else on the shoal. Right there, that day, I lowered over the side a plankton tow-net that I'd borrowed from a friend at the Woods Hole Oceanographic Institution. It was a small one—a conical net about four feet long, of very fine mesh with a plastic cod end screwed onto the tip of the cone, a receptacle about the shape and size of a two-pint ice cream container. I let the net out something like fifty yards and towed it for just five minutes back and forth over the productive hole as slowly as *Spray* could idle, so the water would run through the mesh and not just pile up at the mouth of the net. Then I hauled it in and held it upright and gave it a good shaking, to make sure that as much as possible of what it had caught would go down into the cod end. I detached the cod end and emptied its contents into my bucket and diluted it with about half a pailful of seawater.

I skimmed over the flat Sound to Woods Hole, tied

up at the Marine Biological Laboratory dock, and carried the bucket to my biologist friend's lab in the basement of Redfield, on Main Street not far from the ferry dock. My friend set me up with two microscopes, one with a range up to × 40, the other more powerful, × 160, and gave me some pipettes and a thick slide with a series of small bowl-like hollows in it, and soon, when I had deposited just one tiny dollop of my treasure in one of the hollows and had brought it into focus on the smaller scope, I was suddenly lost in a new world—a new ocean—that made my heart pound.

The sea had come to life. Here truly were things creeping innumerable, both great and small beasts. "Such healthy natural tumult as proves the last day is not at hand." The creatures danced in the water like many motes of fine dust drifting in a ray of sunshine in a room that has just been swept. All of them were actually or nearly microscopic, of course, but some seemed large and menacing, others tiny, passive. I saw under my eyes the subtlety of the Greek word πλαγκτον, plankton, which properly takes several English words to translate: "that which is made to wander." There were both plants and animals, as if in a crowded jungle. Many of them—even some of the plants—could propel themselves in one way or another, and this gave me a sense of how massive, how powerful, the currents of the sea must be, if so many of these fast swimmers are carried helplessly about in them, as wanderers.

Soon, as if unexpectedly seeing the faces of friends in a rush-hour Lexington Avenue subway car, I recognized in this pulsating little drip of the ocean some individuals I'd read about, seen pictures of. Their forms

were as various, it seemed, as the patterns of snowflakes. Here was a diatom, a unicellular plant, its brown-green chloroplast encased in a cylindrical box of silica, with a top fitting over a bottom, exactly like a tiny glass pill-box or jewel case. Other diatoms were like chains of opals, hairy caterpillars, glass rods, pods of seeds, slices of kiwi, ribbons of eggs of the channeled whelk. Here was a *Ceratium tripos*, a mobile anchor-shaped single-celled plant with a little whip to act as a propellor. Here was another barely visible flagellate—whipper—which was, believe it or not, both animal and plant, and which was only about two microns in length: two-millionths of a meter. Here was one of those radiolaria I was talking about the day we met, a cell with an array of fine glass spikes sticking out in all directions. Here was a fish egg, a perfect transparent sphere with a tiny spot from which a life might soon explode. Here, too, in fact, was an astonishing miniature fish, just postlarval. Here were various copepods, "oar-footed ones," strange little insect-like crustaceans with pairs of wide-sweeping antennae. Among them was *Labidocera aestiva*, which my biologist friend was studying. It lays two kinds of eggs, one sort in summer and fall, which hatches quickly, and another, also in the autumn, which falls to the bottom and weathers the winter and is triggered to hatch by the warming of the water the next spring; my friend wanted to unlock the mystery of the clock in the latter. Here is *Acartia hudsonica*, a far smaller copepod than that other, like a miniature cockroach. A *Podon polyphemoides*, a transparent shrimplike beast. The active nauplius, or early larval, stage of a barnacle, a hairy little blob darting here and there. A transparent young arrowworm,

like a miniature version of the pipette I'd used. A weird larva of a mollusc called a veliger, a busy lump with small wings fringed with tiny hairs, looking like riverboat sidewheels, flapping its way around like mad. Suddenly it was approached by a hungry-looking arrowworm, and it at once folded its wings and wrapped itself up into a little rock that fell away from the threat. As a British marine taxonomist, approximately a poet, named Walter Garstang, has put it:

> The Veliger's a lively tar, the liveliest afloat,
> A whirling wheel on either side propels his
> little boat;
> But when the danger signal warns his bustling
> submarine,
> He stops the engine, shuts the port, and drops
> below unseen.

After that encounter I began to be aware that all sorts of crimes were being perpetrated in this driblet of liquid. The muggers were mugging; the killers were killing; the thieves were stealing. A see-through podon was thrashing to free itself from the tentacles of a medusa, a minuscule jellyfish. It came to me that there were two ways of looking at what was happening in that crowded sea in the bowl in the slide: You could see violence, desperate struggles to survive, the will to live, the drive to perpetuate the species. You could also see, though, food chains operating, nature's serene determination to keep in balance all the forms of life.

s : That must have been quite an experience.

F : It was a day of days. But forgive me: I got carried away. You've been whipping the sea—no luck here.

Let's move up to the hole off Leroy Goff's house and see if we can get some action.

s : A lot of my casts seem to plop into the water right beside the boat.

f : You're casting pretty well. Try to release the line with your forefinger a hair sooner; you'll eliminate those flubs and get more distance altogether. . . . All right, here we are. [*Spoken over the side*:] Now is the time for all good fish to come to the aid of my friend— do you hear me, bluefish?

s : Does talking to the fish help?

f : My granddaughter, Sierra, wasn't having any luck one day. I told her to try spitting over the side. She did—and bang! We had one.

s : What you just told me, about the day in the lab, makes me look at the water in a new way.

f : Yes, it's alive. At this time of year you'd probably catch a million living creatures in a cupful of this Sound water. Listen: The plants under the surface of a square mile of the sea may well exceed the amount of vegetation in a square mile of rain forest. And it's thought that there are more copepods in the oceans than all the other animals in the world—of all kinds—put together.

s : I had no idea there was such an abundance of life in the sea.

f : Think of the white cliffs of Dover, how tall they are: They consist of the shell castings and skeletons of countless trillions of plankton animals deposited on a sea floor aeons ago. And, you know, some of those crustaceans I looked at under the microscope at Woods Hole

had tiny droplets of oil in them. All the petroleum under the earth is thought to be derived from the sedimentation of unimaginable numbers of plankton on seabeds hundreds of millions of years ago—apparently made into mineral oil as a product of heat and pressure on those deep layers of fossils. So we drive our cars with energy given us by plankton. And of course the animals among the plankton on those ancient seabeds had derived *their* energy from eating vegetable plankton. All gasoline is grass.

s : You keep talking about food chains. To a land-lubber like me, that phrase suggests the A & P, or perhaps McDonald's. Exactly what do you mean?

f : Let's take ourselves, to begin with. We eat chicken, we certainly eat bluefish, and we eat vegetables and other things—all sorts of proteins, carbohydrates, and fats that have been built up in the bodies of animals and in plants. The bluefish that we eat is in turn a carnivore. It gets nourishment mostly from other fish. Three of the main baits of blues—herring, menhaden, and silversides—are carnivorous, too, yet they live not on other fish but on animal plankton: marine protozoa, crustaceans, the larvae of crabs and sea worms and other small zoöplankton of the sorts I saw under the microscope. Those plankton animals in turn are peaceable grazers, who live on diatoms and those little things with whips—the plants.

The reason all feeding in the sea (as on land, too) has to start with the eating of plants is that only they have the capacity to synthesize life from natural ingredients. They take the riches of the sea—various minerals and salts that have washed down from the land, among

them the phosphates and nitrates of fertilizers, and organic substances like thiamine, B-12, folic acid, amino acids—and with their amazing gift of photosynthesis, using the energy of sunlight, they create new plant life. That new life has all the nutrients and vitamins that animals need, as they convert them to flesh, for reuse over and over again up the chain.

s : Speaking of baits, the blues don't seem much attracted by this jig we're using.

f : Give them time. Patience is the fisherman's primary virtue, though he often pollutes it with swearwords. Is your arm sore?

s : No, no. I love this.

f : You're getting some beautiful casts now.

s : It's like serving in tennis. I'm trying for aces.

f : It was right here, where we are now, that I towed the plankton net that day. I was towing with the net not far below the surface, because that's where most of the plant plankton, and therefore most of those who devour them, stay. The plants depend on light for their chlorophyll to do its work. Fifteen feet down, the intensity of light is only half what it is just under the surface. Naturally you'll have the highest concentration of fish where you have the most plant plankton. The richest fields of vegetable plankton off our coasts, and probably on earth, are out on Georges Bank. That's why in the days of sailing so many Maine and Massachusetts men risked their lives, even in bitter winter winds, and were so often capsized and drowned, going out for the fish feasting in the great banquet there.

Not all the wanderers, of course, are tiny. There are Portuguese men-of-war and jellyfish—

s : I've never been stung by a jellyfish, but the very idea of those tentacles gives me the shivers.

f : Yes—so beautiful and so menacing. Marianne Moore wrote a little poem about what happens if you swim near a jellyfish:

> Visible, invisible,
> a fluctuating charm
> an amber-tinctured amethyst
> inhabits it, your arm
> approaches and it opens
> and it closes; you had meant
> to catch it and it quivers;
> you abandon your intent.

s : Yes, I should think you would.

f : I've talked about marvels out here. Here's one for you: the stinging cell of the kind embedded by the hundreds in the tentacle of a jellyfish. It's really almost unbelievable that such a tricky device could grow in a single cell. It has a mouth, beside which is a tiny hair, the trigger of the cell's explosive weapon. The latter consists of a kind of bladder, like a rubber syringe, filled with a poisonous fluid, running back from the mouth, with a pair of blades folded like scissors near the mouth and a long, flexible needle coiled inside. When the hair trigger comes into contact with anything edible, there is a sudden increase of pressure inside the bulb, and out from the mouth first pop the scissors, opening out to cut an incision in the victim's skin, then the long needle uncoils and shoots itself through it into the victim. When the needle is fully extended and rigid, its tip bursts and the bladder shoots a paralyzing drug into the victim.

It's a hypodermic needle and its barrel, all built into a single cell.

s : What a weapon! I can't say that you've eased my fear of the jellyfish.

f : I know. There are horrors in the sea, and some of them are astonishingly ingenious. I don't want you to get the idea that human beings have a corner on amazing cruelties.

But to get back to business, *we*'ve got to be a bit more ingenious. That jig isn't doing anything. Let's try a different lure. I'll put a Pencil Popper on. Look at it: It doesn't look at all like a fish, does it? Just a tail-heavy white round piece of wood with a hook on it. But it works—floats, makes a fuss as you retrieve it, darts back and forth exactly like a wounded fish on the surface: an easy lunch for a blue, if we can tempt one to come up after it.

Are you bored with casting?

s : Never!

f : I went up last summer to the Stan Gibbs factory in Sagamore, on Cape Cod, where this popper was made. Wonderful New Englandy place. "Factory" is almost too grand a word for it. Just a couple of sheds in a backyard. Man turning plugs out one by one on a lathe, a setup for spray painting by hand, all very simple. As are the lures. None of the fakery of painting them up to look like scared fish. John Gibbs, Stan's son who runs the firm, said the lures' designs are all based on firsthand experience—the family going out fishing off the Cape, watching what fish were eating at various times of year, then figuring out how to make lures act

in the water like the baits the fish were taking. The colors are—

s : Hey! There we are! Fish on!

f : On the second cast with the popper. Why didn't I figure that out sooner? Listen: There's much lighter line on the rod than when we troll. You'll have to play it. The drag is set so it can take some runs and wear itself out.

s : There it goes. What speed!

f : Now gather it in some. Good. There it runs again. Take your time. . . .

I'll gaff it into the boat.

s : You were right the other day. It's as if I've been hooked. My heart is beating so fast.

f : Here's something strange: When a fish is under stress and fighting, its heart goes slower, not faster.

s : Now you have really given me something to envy in the bluefish.

f : Before I put your blue in the fish box, look at the way its body is countershaded, to be as nearly invisible as possible in the water: blue-green on top, just the color of the water as we see it from above, then tapering off down the body to almost white under the belly. In its world, all light comes from above. It moves like a ghost through its haunts.

s : Could I cast some more? Do you have one of these lures with the barbs filed off?

f : Sure. I'll put one on.

s : You were saying about the lures—

f : Gibbs paints them in solid colors to simulate various fish—blue for mackerel, yellow for menhaden.

You'd use the blue in the spring when the mackerel are around, yellow in summer and fall for the pogies. In general, the fisherman's rule is: The brighter the day, the lighter in color the lure. Hence these white poppers today.

s [*casting*]: What sorts of bait do blues attack?

F: Early baits around here are mackerel, squid, herring, and sand eels. Then in summer, silversides, squid, menhaden, sand eels. And in the fall, silversides, menhaden, butterfish, sand eels, mackerel again, and their own young—snapper blues. Lure makers and fishermen want to "match the hatch"—present to the fish something similar to whatever they are eating at a given time. But blues, in case you haven't already guessed it, are quirky. There are days when they apparently won't eat anything offered to them by a human being, except it seems they can't resist live eel, won't eat the whole eel but just chop off a bit of tail. There are times when they'll spurn their favorite bait, menhaden. At other times, when they're swarming, they'll take any lure. Joe Allen, our Vineyard tall-tale teller, vowed that one day he came up on a dragger on which a man with a wooden leg named Deuty Jones was confidently fishing for blues with rod and reel, his hook "baited with an old, used-up blue woolen sock."

s: You've given me a lot of pleasure with poems you've shown me. What you've been telling me just now made me think of an old favorite of mine, John Donne's "The Baite." Do you know it?

F: Oh, indeed I do. It's a favorite of mine, too— but of course it's a lover's poem, not really a fisherman's poem.

s : Perhaps that's why I like it.

f : I think it's probably time to go in now. Do you mind?

s : Who could have imagined, before you hailed me on the dock that afternoon, that one day someone would have to ask me to desist from fishing?

f : It's habit-forming, you know. It may even be addictive.

s : Thank you for warning me.

f [at the mooring, after having cut away one fillet]: Feel this stomach. Hard as a stone. It's just packed. I'll cut it open to see what's in it.

Silversides. Look at them all. See here, some are half digested already. There wasn't room for even one more of these little things in the stomach, yet the fish went for our popper, which is four inches long.

s : If we were blues, and if silversides were money, what would the bigger lure be? . . .

f [entering the kitchen]: Tonight, Barbara, I'm going to cook up something for the Stranger a little fancier than the other times. I was born in China, Stranger, so I'll steam it this time, more or less Chinese fashion, with some Occidental adulterations. Since we're going to steam it, I don't need to skin the fillets; I'll actually be adding oil. For each fillet, I cut up the white part of two scallions very fine, and cut the greens into one-inch lengths. Next I peel and chop fine a half inch of fresh ginger. (This is a smallish fillet, by the way; for a big one, from a seven- or eight-pound fish, I'd increase the ingredients proportionately.) I scatter half the scallions and ginger over a length of doubled aluminum foil big enough to take a fillet, put the fillet on it, and scat-

ter the other half over the top of the meat. I put a table-spoon of sesame seeds in a small frying pan and brown them, just as they are, without oil, watching to make sure they don't burn. Meanwhile, now, I mix three tea-spoons of soy sauce, a tablespoon of dry sherry, a quarter of a teaspoon of sugar, a teaspoon of peanut oil, and a dash of Worcestershire sauce, and add half of the sesame seeds. I pour about a third of this mixture on the fillet and let it marinate for half an hour.

Shall we have a beer? . . .

Now I get water boiling in the steamer. Then I care-fully lift the aluminum foil with the fillet into the steamer, cover, and steam over full heat, following the Canadian rule. While the fish is cooking I heat two ounces of peanut oil in a saucepan and add the rest of the soy-sauce mixture; I get this good and hot.

Fork-test the fish—perfect. I take it out, slide it on a platter, strew a few more chopped scallions and the rest of the sesame seeds over the top, and pour the hot sauce on it—with, finally, a sprinkling of coriander, which seems yearned for by the flavor of certain fish—and even, perhaps, by certain living fish. The ancient Romans used coriander seed as bait for parrotfish.

Can you eat with chopsticks? Barbara prefers a fork.

s : Chopsticks would be fine. Oh, Lord, this is wonderful.

f : *Bu kechi.* That's the Chinese way of accepting compliments: "Don't act like a guest."

THE BAITE

by John Donne

Come live with mee, and bee my love,
And wee will some new pleasures prove
Of golden sands, and christall brookes,
With silken lines, and silver hookes.

There will the river whispering runne
Warm'd by thy eyes, more than the Sunne.
And there th'inamor'd fish will stay,
Begging themselves they may betray.

When thou wilt swimme in that live bath,
Each fish, which every channell hath,
Will amorously to thee swimme,
Gladder to catch thee, then thou him.

If thou, to be so seene, beest loath,
By Sunne, or Moone, thou darknest both,
And if my selfe have leave to see,
I need not their light, having thee.

Let others freeze with angling reeds,
And cut their legges, with shells and weeds,
Or treacherously poore fish beset,
With strangling snare, or windowie net:

Let coarse bold hands, from slimy nest
The bedded fish in banks out-wrest,
Or curious traitors, sleavesilke flies
Bewitch poore fishes wandring eyes.

For thee, thou needst no such deceit,
For thou thy selfe art thine owne bait;
That fish, that is not catch'd thereby,
Alas, is wiser farre than I.

July 12

FISHERMAN: Are you awake?

STRANGER: Not exactly. I'm not used to getting up at four fifteen. It's pitch-dark.

FISHERMAN: Not quite *pitch*-dark. Anyway, the whole point of dawn fishing is to come out just before daybreak. The change from dark to light is what matters. During the lightening at dawn and the darkening at dusk, blues are especially voracious. They have complex clocks in them. Instead of being regulated by springs and gears, their timepieces are regulated for the

most part by light and dark, and to some extent by heat and cold. Light is the strongest influence; the rhythms of their lives are set by the varying lengths of daylight through the seasons. We all have inner clocks. Yours rebels against being hauled out of bed at four fifteen in the morning. Are you a night person?

s : Yes, I most certainly am.

f : You're an owl. I'm not. I'm a catbird. I'm at my noisiest in the morning, so this early start isn't quite such a wrench for me as it is for you.

s : Everything on the boat is soaking wet!

f : That's the sweet dew of the night. Wait a little while. The rising sun will cheer you up. Catching a blue will get your heart pumping.

s : I'll believe it when it happens.

f : Look, the West Chop light is still on. The white flash out here in the "safe" arc comes every four seconds. And see Nobska over there, every six. Each in its rhythm measuring the time we have left to be alive. We must make use of it!

Bluefish use every minute. They don't go to bed at night and go to sleep. They swim both day and night. They never stop. Tautogs—sometimes called blackfish around here—really go to sleep at night. They lie down on the bottom and sleep so soundly that you'd be able to dive down to a ten-pound fish and pick it up with your hands. But the bluefish, being a hunter, is ever ready. At night the blues' school breaks down, and each fish swims alone, deep in the water, in a beautiful slow drift. If a light is flashed and it sees bait, it begins feeding right away. In general, though, the night is a time to save energy for the hunting of the day.

Look: There's a glimmer of light to the east.

Now, here is why we're out at this hour: During the night, fish of the size we've been catching glide drowsily along at a rate of something less than seven inches per second. They idle all night without eating. They become famished. A few minutes *before* dawn—just about now —their inner alarm clock goes off, and they begin to rove. In the first ten minutes after the onset of light in the sky there is a sudden upsurge in their swimming speed; they have started at once to range for food. Twenty minutes after daybreak they put on the greatest spurt of the twenty-four hours and swim between twenty and thirty inches per second; they're capable of much greater speeds when attacking a prey. The sun will come up over there, about where Hyannis lies beyond the horizon, in just a few minutes, at five twelve. So we should be on the alert for some fast-swimming blues at between five twenty-five and five thirty. Just about when the clock down in the cuddy strikes three bells, we should hook a fish.

s : Why three bells at five thirty? Isn't there something wrong with that arithmetic?

f : Ships' clocks are chimed every half hour to the rhythms of the lives of sailors at sea, who work and sleep in watches of four hours apiece. Each watch is relieved at eight bells on the clock, which comes at the hours of four, eight, and twelve. At four thirty this morning, then, the clock struck one bell; at five, two; and at blue-catching time, it'll ring three bells.

I'll use dark brown Rapalas this morning; they're "swimmers" like Rebels. Dark lures for dim light. Here, you let your line out.

s : I would find it awfully hard to have to work and sleep in four-hour stretches.

F : You'd adjust. Sailors do. Bluefish do. Some years ago, having established the normal rhythms of blues' swimming in response to daily flooding and ebbing of light, experimenters subjected some blues in a tank to a skewed cycle of light, delaying light and dark by seven hours. The fish lagged in their swimming patterns in a sort of confused protest against the shifted cycle—just like us with our jet lag. And rather like you this morning, Stranger. By the fourth day they had adapted themselves to the new schedule. Maybe, for your sake, we should come out for four dawns in a row.

s : Thank you. That will not be necessary.

F : Next, the observers subjected blues that had been on a normal daylight schedule to a constant dim light, never changing, and then do you know what happened? The daily rhythms persisted, hung on, which suggested that the blues' inner clocks were fairly closely set to the light changes of the days and nights of that phase of the season.

Speaking of changes, the tip of the sun is just about to show itself, probably right over the Kennedys' compound at Hyannis Port.

s : How superb that sky is.

F : Ah, good, you've begun to come to life. Five twelve. There's the rim of Apollo's chariot now. Look ahead, you can begin to see the rip along Middle Ground.

s : I'm glad the day is coming at last.

F : One short day. We've been talking about clocks, but we haven't mentioned the big one.

s : What do you mean?

F : Do you know how old the sea is? Stranger, you worry about whether you get up at four fifteen or nine fifteen in the morning of one day: Do you know how many days the oceans have existed? Geologists, who can calculate the age of rocks, have found some in the Karelia Peninsula in the Soviet Union and in South Africa which suggest that the earth may have arrived on the scene something like four and a half billion years ago. Allowing for cooling and aeons of steam and then unthinkable millennia of freshets of rain, we can guess that the oceans may be four billion years old.

The first living things to appear in those seas, how many ages later we cannot know, were probably tiny complexes of organic matter in the water, not quite plants, not quite animals, something like certain of today's iron and sulphur bacteria, that could somehow live on inorganic food and replicate themselves. When the sun finally broke through the clouds, the miracle of chlorophyll must have come along—so that the diatoms I saw in the microscope that day in Woods Hole may have been the second order of living things. Then multicellular creatures: animal plankton. We're talking about passages of hundreds and hundreds of millions of years.

The most ancient vertebrates were armor-plated fishes in the Ordovician period, more than four hundred million years ago. Back in the 1930s, fishermen netting in the depths off South Africa astonished scientists by catching a fish called the coelacanth—a creature that until then had been observed only in fossils from the Devonian period, more than three hundred million years ago. Here it was, still alive, having outlived the dinosaurs, among other animals.

The second oldest surviving fishes are the lungfishes, off Australia, South America, and Africa; they have lungs and can breathe air. They represented a bridge to land animals—to us. They live in shallows that dry out for part of the year, so they have to be able both to take oxygen from the water and to breathe air. When the water table falls, they make a vertical burrow in the mud bottom and retreat into it, finally secreting a cocoon and lying dormant within it, in the dry clay, until rains come again. I'll show you an amusing poem tonight, with quite a bit of marine biology in it, which John Ciardi wrote about this persevering creature—our link with antiquity.

The most ancient sea beasts we can see around here with the naked eye are horseshoe crabs; you may have seen them copulating, little male atop big female, along our beaches, still out for a bit of fun after two hundred million years.

By the way, it's five twenty-seven. The blues ought to have worked up to pretty good cruising speed by now —let's say twenty, twenty-five inches per second. Maybe you'll get a hit soon.

The bony fishes—which blues are—didn't appear until the Mesozoic era, and weren't numerous until the Cretaceous period, perhaps a hundred million years ago.

s : So bluefish may have existed for a hundred million years?

f : Blues aren't necessarily among the older bony fishes. We don't know exactly how long they've been around—one of the mysteries. Like the mystery of the periods when they're *not* around. I told you about the way they seem almost to drop out of existence from time

to time. Joe Allen, who liked to crank out light verse, wrote some lines about one of those times, fifty years ago, when the oldsters, remembering earlier days when they had plowed under tons of huge bluefish as fertilizer because they'd caught so many the markets were glutted, lamented that "never more/Such fish again would head this way." But fifty years later, he wrote, they were back, and anglers swarmed out to catch them.

> They boast of landing even one;
> They dare not wait for them to grow.—
> How altered are ideas and men,
> And fish; since fifty years ago!

We can assume that bluefish have been evolving into their present form for—

[*The clock in the cuddy strikes three bells.*]

s : My God! I can't believe this. I have a fish on.

f : I can hardly believe it, myself. I've caught fish nearly on the moment of the expected time, but never had a hit announced by the chimes. Wonderful! Perhaps your clock, Stranger, and the boat's clock and the fish's clock were synchronized somehow. . . . Nice work, you're playing them skillfully now. For one who had such strong feelings about killing fish, you've turned out to be a natural fisherman, like my grandson Cannon. Maybe when you were born your mother threw your umbilical cord into the sea, the way Fijian women used to do, to make their sons good fishermen.

s : I doubt it. We lived in Ohio. But thank you for the compliment. And I have to admit that having gotten up so early, I don't really want to go back in yet. Could we try for some more, and give them back to the sea?

F : Fine. Just let me put some water in the fish box, and change the lure.

Middle Ground, now, is very young. The Pleistocene epoch, with its glaciers, began about a million years ago and lasted till about ten thousand years ago. It was very late, during the final spasm of the ice age, called the Wisconsin stage, a little more than fifty thousand years ago, that snow fell in the winters on the heights of Labrador much faster than it could melt in the summers. Gradually its own weight compressed it into layers of ice, and when these grew to hundreds of feet in depth, they began to spread to lower ground. The snow fell and fell, until the ice was something like ten thousand feet deep, and it pushed out over all of New England. Its forward edge, like a bulldozer's blade, scoured bedrock (itself, in this area, possibly half a billion years old) and heaved it and ground it along the way. By this time so much moisture had been lifted from the sea into the snow and ice that the shoreline had moved out about eighty miles from where it is now. The ice at the farthest southern edge of advance of the Wisconsin stage lay dormant for thousands of years, and as it finally melted and pulled back, refilling the ancient reservoir, it deposited part of Long Island, to Montauk Point, and Block Island, Martha's Vineyard, and Nantucket. The edge melted back some distance, then new snows fell and it moved forward a short distance again, this time dumping its till to form the north shore of Long Island, Fishers Island, the coast of Rhode Island, the Elizabeth Islands over there, the east rim of Buzzards Bay, and Cape Cod. Presumably it was during the complex depositing of the earlier moraine, which formed the Vineyard, that a minor

perturbation of the floor of what we now call Vineyard Sound, a little wrinkle of glacial debris, was strung out here, and abracadabra! Middle Ground.

s : Which would have been when?

f : Let's guess something like twenty thousand years ago, or perhaps a bit less. Very recent.

s : Are there glacial boulders along the shoal, then? Do ships get wrecked along here?

f : No. When the ice sheets melted and the sea returned, tidal currents in the Sound piled up soft sand on the underlying ridge, and the molding movements of the water have kept it there ever since. Late one afternoon two summers ago I had the most astonishing view of the shoal. It had been calm for a couple of days, and the water was unusually clear. There was not a whisper of breeze, it was slack tide, the water's surface was the glass face of an aquarium. The huge lens of the sky had no filters. The sun was low, and its bright slanting rays were refracted downward into the water and shone like the light in a fish tank. And there the shoal loomed, ten feet down. Do you know what it looked like? It looked exactly like a great long dune, seen from above, in the Sahara Desert. The sand undulated and was ridged with ripples, formed not by moving wind but by moving water, and there were lips at the edges of the crests. At the "holes" there were scoops, dips. Here and there, as the shoal took slight turns, long drifts tailed away. And down on either side, deeper, where even that extraordinary light failed, there was—I could sense it, almost feel it, almost inhabit it—the dark lair of the bluefish. It was as if I were dreaming. I had the most amazing sensation, then, of gaining through that dream a particle

of knowledge of what it meant to be a bluefish—and of what it meant, for that matter, to be myself, swimming through the dream in this upper realm of air and light.

s : I envy you that vision. I have been haunted, myself, since I first started coming out with you, by what has seemed to me the impenetrability of the water's surface, at least by my eyes. Each time I've come out, the sea has reflected the sky as if its surface were as hard as that of aluminum or polished marble, and this has made it difficult for me even to imagine what it would be like to be a bluefish, down under there. I remember that on that first day, in trying to get me to soften my bias against fishing, you urged me to bear in mind that in the act of foraging for food, we'd really be trying to find our appropriate place in the systems of life on earth. The many things you've told me have certainly begun to sensitize me. But ears can't see. I blame this hard face of the water, and my consequent "blindness," for my sense that I'm a long way from finding and accepting my relationship to the bluefish. I wish I could glimpse the shoal and that "dark lair" you spoke of.

F : Maybe the conditions will be right one of these days.

s : You said the shoal had been shaped by moving water. I've been wanting to ask you: How do you know before we come out what the current is going to be doing? You seem to know, each time.

F : You see, there we have another kind of clock. The currents here are not like the hot Gulf Stream or the cold Labrador Current, which run forever like great rivers in the sea; here the currents seasaw back and forth, twice a day each way. They are caused by the water's

yearning for the moon and the sun as those two pass overhead each day; the waters rise and fall and, along our shores, tend eastward. When tides move in and out of narrows, their surge and suck set the waters in motion. In some places, these motions cause havoc. You'll remember Charybdis; it's in the Strait of Messina; its whirlpools are so powerful that they dredge up fish from the abyss with eyes dimmed out of existence by the depths, or with huge bulging eyes to see what they can in the morose shadows of their natal Hades. There's a river in China, I think it's called the Qiantang, where the tide advances upstream from the mouth twice a day in a "bore"—a single hideous foamy wave, ten to twenty feet high. And did you ever read Poe's "Descent into the Maelstrom"?

s : I certainly did. I read it when I was a boy. For years it made me afraid to flush our toilet, because the descending water had a kind of whirling motion. I thought if I wasn't careful I might wind up in the sewer.

f : We don't have anything quite so disastrous around here, though where the currents run through very narrow gaps, as at Woods Hole and the other holes up the Elizabeth Islands, they can be extremely dangerous to any mariner who doesn't know what to expect. And we've talked, I remember, about the violent water, sometimes, off the Chops. It's a bit surprising that currents hereabouts have the force that they do, because the rise and fall of the tides around the Vineyard are only a couple of feet on the average; they're as much as fifty feet in the Bay of Fundy.

The moon's influence on tides is twice that of the sun. Each circuit of the earth by the moon takes fifty

minutes more than twenty-four hours. So it's possible to predict what time each day's tides will be high and low in any given place. Tides are not only inexorable—King Canute couldn't stop them—they're also dependably periodic. I have two ways of knowing when the best times to come out will be. One is a marvelous book of tide tables for the waters of this area, called *Eldridge's*. You can figure from its pages the times of high and low tide at various places on Vineyard shores on any day of the year; what's more, it has a series of charts with little arrows showing the direction and velocity of currents in these waters at each hour of rise and fall. The other indicator is an actual tide clock. Some of our friends are amazed that I can have a clock to tell me the level of the sea, but of course it's simple: It's a regular clock with twelve and a half extra minutes (a quarter of the moon's daily foot-dragging) squeezed into each six hours, and with a hand that points to stages—

s : Wait! There's one! Oh, this is a good one!

f : The one you have to throw back always is.

s : I think it's off. The line's gone dead.

f : Yes, you lost it. Don't worry. It happens. You have to keep a constant pull on the line, or the fish'll shake the hook out. One thing I've noticed: You should keep the tip of the rod higher. The bend of the rod then helps keep the pressure steady.

s : I'm disappointed. I thought I was getting somewhere.

f : Put it out of your mind. I lose them once in a while. These fish aren't stupid. They want to live.

s : Can I try once more?

f : I have all day. All of one short day. I'll try the

place where that one hit. You'll have another one on in half a minute. . . .

s : God's teeth! I have.

f : Rod up. Good . . . there.

s : And you have to throw it back.

f : Yes. There is "a time to be born and a time to die; a time to plant and a time to pluck up that which is planted; a time to kill and a time to heal." And "a time to keep, and a time to cast away." And, for that matter, a time to fish and a time to go home.

s : If we must.

f [*as* Spray *approaches the breakwater*]: You look a thousand miles away. What are you thinking?

s : I'm thinking about clocks. About how long it took for all the plankton to make the oil fields, and how fast we're burning them up. Every time I drive to Cronig's for groceries now I think, "My God, in those five minutes I just burned ten zillion copepods."

f : That's probably a pretty good estimate.

[*At the mooring*:] Look, do you see this spot behind the pectoral fin? It's far brighter than normal. That's a sexual signal—these blues are about ready to spawn. [*Having taken one fillet off*:] Aha. Yes, sir. A ready female. Look at this ripe roe.

s : It looks awful—that orangy color. Is it edible?

f : I tried it once. Didn't think much of it.

s : How many eggs would you say there are?

f : In a blue of this size, somewhere between six hundred thousand and a million four hundred thousand. I'm told a female sturgeon ten feet long may carry more than three million eggs weighing altogether two hundred fifty pounds. At the price being charged for top-of-the-

line caviar in New York right now, that load in one fish would be worth about sixty thousand dollars. Too bad fishermen can't scoop money like that out of blues.

s : As you say, fishing is complicated.

f : We'd better go out again soon—in a very few days. After that the fish will be gone for two or three weeks, to beget.

[*They go ashore, and they part for the day.*]

f [*at the door, in the evening*]: Come in. Before we join Barbara, let me show you a chart of these waters made by a British naval officer in 1779.

s : Look at that! Every house on all these shores is marked—Nantucket, the Vineyard, Newport.

f : That's not the point. The point is that the sands of Middle Ground are—at least within imaginable time spans—immutable. You could use the soundings on this chart out there today with absolute security.

[*In the kitchen:*] This afternoon I made a marinade of five tablespoons of vermouth; a tablespoon and a half of soy sauce; a half inch of ginger root, peeled and diced fine; a half dozen sprigs of fresh dill, cut up; and a clove of garlic that I'd put through a press. I skinned the fillets and cut the meat into one-inch cubes, and marinated them for three hours, turning them from time to time.

Now I make some straightforward pancake batter, following a recipe in *The Joy of Cooking*. I add an extra egg to it.

Next let's heat some vegetable oil in a deep fryer. Watch it for me, would you please, to make sure it doesn't froth up; if it starts to, take the fryer right off the fire. Fresh vegetable oil shouldn't boil, but you never know. Meanwhile I'll dredge a number of cubes of the

fish in flour, and put a platter in the oven to warm it up. . . .

I think the oil's good and hot; it's smoking. Now, using a skewer, I spear a cube at a time and dunk it in the batter, making sure it gets completely covered, and then quickly pop it into the hot oil, pushing it off the skewer with a fork—careful not to splash. I'll do about a half dozen in the first batch. Cook for not more than five or six minutes. Remove with a spoon with holes in it to the hot platter. Do a second batch. And a third. And serve.

s : Oh my, this is swell. I can't tell you how much I've enjoyed these dinners of fish.

f : Yes. "Fish suppers will make a man hop like a flea."

THE LUNG FISH

by John Ciardi

In Africa, when river beds
 crack, the lung fish
squirms into mud deeper than
 the two feet down of wrath, and

sleeps, its tail over its eyes
 to keep them from drying blind, its
snout at the blow-hole blueprinted
 in the egg, too small to read,

but read. No one, the lung fish least,
 knows how long it can wait. If no
creature is immortal, some
 are more stubborn than others.

If all sleep is a miracle, consider
 (through the poking lenses
of unraveling science) what
 miracle this is: The lung fish

digests its own tissues. Its wastes,
 which are normally an ammonia
safely dispersed in water, would
 in its cocoon, choke it. Therefore

it changes them to urea, which
 it can live with. Lung fish blood

is known to have six different
 hemoglobins—four more

than Moses took to God's desert.
 Like Moses, it has gone to legend
in Africa. It is said to be
 half fish, half croc. It is called

Kamongo there (but does not answer).
 If you cut off its head
(whether in fact or legend, and who
 knows which?) its jaws will snap

two days later. (Which
 we do know, all of us, about
what we cut off.) When
 Dr. Brown, an ichthyologist

of Seattle, put Kamongo
 into a mud bottom aquarium
and lowered the water level, as God
 does at whim, this egg-born

instinctus of survival slept
 seventeen months. When it woke
in the reconfluence of time
 and whim, it seized stones with its mouth

and dinged them against the world's walls
 till it was fed—dinged them so hard
the doctor thought the walls might break
 between him and his creature. He drained it

back to sleep for time to build a world
 strong enough to hold both sleep
and waking. If anything can be. If we
 can learn sleep whole and not choke

on what we are while we learn it.

July 16

FISHERMAN: We might get skunked today.

STRANGER: Skunked?

FISHERMAN: Come home without a fish. I would have to lie to Barbara about "the ones we lost."

STRANGER: You have a wife. You may lie. Bachelors never lie.

FISHERMAN: Of course not. Now that you're such a good and honest angler, you put me in mind of the philosopher who gave us the claim of truth that could not possibly be true: "I lie when I say I lie."

STRANGER: Thank you for calling me a good

angler, but my tests of truth, as you know, are those of a person who is used to having his feet on solid ground. Why, though, might we get skunked?

s : You saw that ready roe the other day. Schools of blues apparently spawn in series along the coast, with the peak in this area coming in July and August; and while they seem to go out in relays from Rhode Island and Massachusetts waters, it has been my observation that the schools that hang out in Vineyard Sound usually vacate all at once, and we have a period of three weeks or so each year when they just aren't on Middle Ground at all. On the other side of the island, off Katama, or down near Nomans, in that time, fishermen may still be catching a few blues; not here, most years. But maybe the locals haven't altogether cleared out by now. We'll see. I just suspect that we'll have to work a bit harder than usual to find them.

s : How do you mean, work?

F : Well, even if they're here, they won't be very hungry. Here's one time we can ichthyomorphize: Just like bluefish, human beings who are in love and ache for sex get picky about food.

By way of work, we'll troll awhile up here at the West Chop end, and maybe try the hole off the Goff house, and if those places don't work, we'll go out along the shoal, maybe even right out to the other end, three miles out. Sometimes they move out to the west along the shoal in the last few days before they go trysting. We'll try different lures, sometimes on the surface and sometimes deep. We'll just keep at it, that's all.

s : I'm game.

F : Good. It's sunny today, so I'll put on a blue

Rebel and a yellow one; maybe the lighter one will work in this brightness.

While we get started, may I tell you about an experience I had last winter that was almost as exciting as the one of seeing the plankton through the microscope?

s : Please.

f : I have to tell you first about a shocking tragedy. Out at the tip of a long finger of dune reaching up around a quiet bay from the bluffs of Highlands, New Jersey, there existed for many years one of the most beautiful facilities in the world for the study of fish life. In an old building, one of many remnants of a World War One army post known as Fort Hancock, a large holding tank was built by what was then called the Sandy Hook Marine Laboratory—later renamed the Northeast Fisheries Center of the National Oceanic and Atmospheric Administration. The elliptical tank was thirty-five feet long, fifteen feet wide, and ten feet deep, and it held thirty-two thousand gallons of filtered seawater. In the room there were almost perfect controls of environmental conditions—of temperature, light, and sound—so that fish could experience day and night and seasonal changes almost as if they were in the wild. There were windows around the sides of the tank, to watch the fish through. In that tank for two decades marine biologists and animal behaviorists conducted hundreds of exquisite experiments, mostly on bluefish. Indeed, much of what we human beings know as dependable fact about our fellow animal the bluefish was observed in that body of water.

On the windy night of infamy of September 21, 1985, an arsonist set fire to the laboratory.

s : Oh my God.

f : Did I say, Stranger, the first day we went out, that you might think *Pomatomus saltatrix* vicious? When I heard of the fire, I wondered what vile excuse for the species *Homo sapiens* could have done such a thing?—a numskull kid who'd watched too much celebration of arson on TV, an insane disgruntled former employee, a loony fish hater, a flame-loving sicko? I had read, always with a thrilling sense of discovery, scores of studies done in that building. The news of the fire literally made me feel ill; it seemed an affront to everything I value in humanity—was just as bad as a wanton act of terrorism or a racist atrocity.

s : Oh, I agree.

f : Anyway. A fire company had to drive all the way out the Hook to get to the building, and by the time the engines arrived the wind-fed flames had totally demolished the lab. Everything—except the mocking shell of the tank—was lost. Almost all the data of all the years, priceless treasures of loving study, were destroyed. An idiot had burned knowledge.

A pathetic madman, as it turned out. Eight months later a ranger in the adjacent Gateway National Recreation Area—a man who had been assigned as a firefighter in the park's firehouse, and who had fought forest fires in Idaho—confessed to eight separate sins of arson, including the one that destroyed the fisheries lab. Having told his story, he shot himself dead with a forest ranger's handgun.

When the staff of the lab got over their shock, in the days after the lab burned, they raked through the ashes and retrieved what they could. One precious thing that

somehow survived was a short film of blues feeding in the tank, and one of the Sandy Hook scientists made a copy of it for me and gave it to me as a present. And one day last winter, using the projector in the lecture room of the Key West public library, I watched it.

After all the years of fishing for blues and trying to visualize what must have been happening under the surface—under the mirror of the sky that you were complaining about last time—I was finally able, sitting there in a house of books, to go into the water with six blues, to enter right into their medium and swim with them.

At first we were in the murk of breaking dawn. The fish schooled, paddling gently and coasting. They went their rounds. It grew lighter. The pace quickened. Then the blues began to hunt. The school broke; each was on its own. The great forked tails drove the fish faster and faster; you could see the huge engines of their flank muscles working. The fish were crafted from flexible steel, the countershading under the light from a neon sky making them appear one solid submarine color not much different from that of the water—save for a bright spot, appearing luminescent, or like a porthole lit from within, at the forward base of the pectoral fin on each side, in back of the gills. Was this spot a mark of recognition of its kind each could make out from a distance in the shadows of their world?

For a time the film stalled into slow motion. As each blue drifted past me, the hostile near eye—which you remember, Stranger, I had distinctly not wanted to face under water—pivoted buttonlike to focus on me, its curiosity laced with a fierce territorial strictness; then, as the fish surprised and relieved me by negligently sailing

along, the button swung to a more forward beam. It had not been quite as bad as I had feared; this was hunger time; I would not be good to eat, or even worth judging. One fish opened its mouth and moved its tongue, as if trying to test whether there were any spoor of baitfish— or perhaps bad taste of human beings—around.

The film broke back to full speed, and the blues, on the alert, were whizzing past me like shooting stars in an August sky. Suddenly the smooth bright lid of our universe was broken in several places, and a handful of mummichogs, robust and chubby four- and five-inch light brown fish with dark bars along their flanks, tossed from above, swam downward from the surface. Not far. Up from below, like rockets, their powerful tails driving so hard as to seem to flutter, the great bodies flashed. They were going so fast that they had to open their mouths two or three feet before they reached the bait—and how those saw-edged caverns gaped! Then the doom chop of razor teeth and a sudden sharp swerve to right or left, and a spurt downward to be ready at once to kill again. More mummichogs. All around me there was an appalling energy of devastating missiles, almost always shooting upward to keep the targets framed against the morning light. Sometimes the charging silver-gray parcels broke the shining surface overhead and then cut away downward, leaving a wobbling and bubbling ring of turmoil up there. Soon there began to be what looked like a snowfall of neglected bits of bait, chopped away from what had been gulped, drifting toward the bottom. Other gobbets, floating, speckled the surface.

It was all happening so fast—far faster than I can tell it to you—that it took me awhile, with the help of

some slow-motion footage, to notice two apparently important things. One was that as the fish charged the bait, their eyes swiveled far forward, so that even though the bright buttons were fastened to the sides of their heads, they appeared able to afford the fish direct forward binocular vision: vision, that is, with depth perception. So apparently sight—speed of eyes—was vital. There was one incident when two blues saw the same mummichog at what seemed the same moment and rose in beautiful parallel entrechats; but one's eyes must have been a millisecond faster than the other's, and it got to the food first, breaking away to the right as the other, beaten, broke away just as fast to the left in order not to be beaten again. The other thing I saw was mysterious to me—and remains so, I gather, to the scientists: As the fish fed, they kept flashing their twin pelvic fins. Most of the time, while swimming, they kept these two fins, located on either side underneath their bodies at the forward end of their bellies, tucked up tight. But on the charge, while feeding, they kept dropping them to their full extension, like sailboat hulls letting down double centerboards. But very fast. The word for this action had to be "flashing," because the transparent fins peculiarly picked up the dawn light, much more than any other feature of their bodies, and shone like hurtling bright signal flags.

Gradually, as the fountain play of ravenous flesh progressed, and as satiety—the faintest possibility of which had so recently seemed quite out of the question—actually began to set in, the upward surges continued but seemed to lose, bit by bit, their murderous urgency. The semaphore signals of the flags, whatever their code, were less frantic. The huge propellant tails eased their drive.

Not that a single mummichog swam free of its fate; there always seemed to be room in some gullet for just one more. But the ceremony was working itself out.

Finally the morning repast was over. The fish slowed their pace to normal cruising speed. Having competed with each other like Greek athletes, to the utmost limits of their resources, they now shaped up and went back to school. I must say, though, that at this point they looked more like professors than scholars, with their distended paunches, and their calm collegial air, and their look of having known all along that things would be this way.

s : How wonderful! Thank you. That makes me feel as if my eyes have finally penetrated the surface, and I can visualize what happens when we get a strike.

f : But with a difference: That scene must have been what it's like when the blues swarm to the surface, attacking a big cloud of bait. Our fishing here, most days, is a matter of persuading one or two of a small school to come up for supper—our supper. I'm hoping, though, that one day I'll be able to treat you to a swarm. I come on a huge school working the surface two or three times a summer here.

s : I certainly don't want to identify with baitfish, but since I've been coming out fishing with you—and just now when you were talking about feeling as if you were *in* the tank during the slaughter of the mummi-chogs—I keep having this image of the fisherman being caught by the fish, instead of the other way around.

f : Yes, you teased me with that fantasy the other day. Could it have to do with the ticking of clocks out here? "The Lord God hath sworn by his holiness, that,

lo, the days shall come upon you, that he will take you away with hooks, and your posterity with fishhooks"?

s : Maybe that's it. In bed the other night I kept thinking, as if I were having a bad dream, about the passage from the *Odyssey* when Odysseus sailed past Scylla and Charybdis. I love Robert Fitzgerald's translation, and I've read it several times. Scylla plucks a half dozen of Odysseus's best men from the ship, and Homer gives a vivid picture of their being ripped like fish "from the surface/to dangle wriggling through the air."

F : I try to remind myself, each time I lift a fish out of the water, and see it struggling that way on the line, that there's a sufficient reason for my taking its life: the harmony of the chains of existence.

s : That's fine, because you consider yourself the top link in the chain. Mightn't it be that some other creatures—viruses, let's say, or the worms of the graveyard—are links above us, or beyond us, in the chain?

F : You're right, Stranger. We, too, will be played on the end of a line, sooner or later.

s : I hope I'll have as much courage as a bluefish, then.

F : I plan to make some runs and jumps. I'd like to have learned from these blues.

s : I hope I'm learning from you how to learn from them. One thing I've been finding out on these trips is that it's not easy to shake my anthropocentric past. I realize that my landsman's habits of thinking—mostly about my relationships with human animals—may have been blinding me, as much as the mirroring surface of the sea has been, to the unfamiliar life beneath it. It all

comes down to wanting to *see*—to penetrate the mirror and not just see one's self and one's own world. . . .

One thing I do see is that you're moving out on the shoal.

F : There aren't birds around this end. Keep your eye out for terns: They're our best guides at this time of year. I think I'll put a lead sinker on one of the lines, try deep trolling—with the blue lure.

S : You have blue and yellow on the lines. Can the fish tell the difference—beyond just light and dark?

F : They can. Most mammals can't see colors. The bull being angered by red is a myth. The few beasts Nature has chosen to endow with color vision make a club of odd characters: us and other primates, turtles, lizards, insects, birds, and the bony fishes. Black-and-white for all the others on Noah's ask. Some fishes can see colors we can't. A researcher at the Woods Hole Marine Biological Laboratory discovered that the Japanese dace, *Tribolodon hakonensis*, called *ugui* by the Japanese, can see ultraviolet rays, way at the bottom of the shortwave range. What's more, taking color pictures of the fish with an ultraviolet filter, he revealed two stripes down the fish's belly that we human beings can't see—stripes that may help the fish to recognize its own brothers and sisters. Fish give each other signals by changes of color on their bodies. You remember I pointed out the inflamed spot behind the blue's pectoral fin the other day? By that bright blush she was giving a message to male blues.

S : I'll never get over the stare the blue gave us that we caught the first day we went out, and I was fascinated, when you were telling just now about that film,

by what you said about the eyes—their importance in feeding, and the way they could swivel around.

F : Blues' vision is different from ours in ways it's hard even to imagine. First of all there are structural differences in the eye itself. The basic elements are the same: cornea, iris, lens, retina. But the iris of the fish doesn't open and close like ours to let in more or less light; and whereas our lens is oval in section and focuses by being made thicker or thinner by special muscles, the fish lens is and stays spherical, and focus is achieved by a set of a different sort of muscles moving the lens back and forth, here and there, within the eye.

The biggest difference, of course, and to us the eeriest one, is that the eyes are on the sides of the fish's head, so it can see almost all around. Like having eyes where our ears are. You must have gotten the creeps, as I have, seeing pictures taken with what photographers call a fisheye camera lens; it puts you within a kind of globe of vision. Each bluefish eye is independent of the other —can wobble about to look in one direction on one side and quite another on the other. I get woozy talking about it. The two eyes can, though, work together for forward vision. There are a couple of blind spots—dead astern, and, like ours in a car for the few feet of road in front of the hood, for a short distance in front of the nose.

Blues have no eyelids, so can't blink; and of course they have no need to shed tears, since the salt sea washes woes away, as well as motes and beams. There are wonders in fish eyes. Sometimes I fish on the bottom out here for fluke and flounder. When these are juveniles, they swim around upright like any other fish, with an eye on each side; but later they lie down for the rest of

their lives, on one side on the bottom, and one eye grad-
ually moves right up through to what is then the top of
the head, so they wind up with two eyes on one side—
Picasso fish, I call them. Then there's the four-eyed fish,
Anableps anableps, which glides about on the surface,
with one pair of eyes under water and one above, looking
for food in both air and sea. The oceanic spookfish—
really!—has eyes on top of barrel-like cylinders and can
only see upward. The stargazer, of the family Urano-
scopidae, is a toadlike horror that buries itself in the
mud, with only its eyes and mouth showing; a wormlike
thing dancing out of the mouth lures little fishes, and
when they come close, electric organs derived from the
stargazer's optic nerve shock them into insensibility with
fifty volts, and down the mouth they go.

s : "If looks could kill . . ."

f : On a clear day we can see through air for miles;
in this plankton-busy water blues probably can't see
more than forty or fifty feet. But within limits their
vision is very keen. The people at Sandy Hook thought
that blues may be able to see lures cast through the air
before they hit the water; at the tank they would throw
fish to the far end, and the blues would follow them at
tremendous speed and grab them as they landed. And
stream fishermen know that a trout seems to be able to
distinguish ahead of time one sort of tiny arriving fly,
which it will want, from another, which it won't.

The blue's eyes are on the lookout not only for prey,
of course, but also for predators. There's that dangerous
blind spot to the rear—the lateral line may help some
there.

s : What fish do eat blues?

f : Their sprint speed in swimming makes blues safe from all but the swiftest big fishes—sharks, tunas, swordfish, wahoo. None of those wallhangers venture into the Sound, so all the blues have to fear here is me and thee.

s : Who seem not to be doing so well today.

f : Alas. And we're already way out here off the Tashmoo opening.

I tell you what: Bring the lines in, and I'll try something. I'll spray some of this fish attractant on a Hoochie, and see if it helps. It leaves a trail of odor in the water.

s : Does it work? Can fish *smell* under water?

f : I bought this stuff a while ago to try it. Frankly, I suspect it was designed for freshwater fishing; it doesn't seem to help much out here, but today's a day to try anything.

All right, let your line out.

Yes, fishes certainly can smell under water—smell and taste. They have pairs of small holes on both sides of the head, above and forward of the eyes; and water constantly flushes through the forward holes and out the rear ones, passing over sensors that pick up odors. As for taste, fishes have taste buds in other places besides on the tongue. The whiting has them on its fins. You probably wouldn't think of the catfish as a gourmet, but it has taste buds on its lips, its fins, its feelerlike whiskers, and even on the skin of its body. Blues, who chop and gobble, probably don't count so much on taste as some other fishes do.

Yet I've seen blues caught by a technique of fishing

called chumming: You drop dollops of a slush of moist-
ened, chopped-up bait as you drift along; the fish pick
up the smell and taste of the trail and come up to your
bait on the line. In fact, fishermen long ago learned that
certain odors on lures attract fish, and others repel them.
Chum may be made from chopped-up fish guts; oil from
menhaden and herring definitely helps. For centuries
freshwater anglers have used squashed worms, maggots,
bloodsuckers, crayfish, and so on, to enliven the scent of
their bait. Cheese and human saliva seem to attract some
fish—though I don't think it was my granddaughter
Sierra's spit that caught us the fish that day, just luck.

s : What are the bad smells?

f : Some fishermen just can't figure out why they
have no luck while others around them are catching like
mad. They're people who, before they go out each time,
pour gas in their outboards and get their hands fouled
with motor oil, and then handle their lures. If I may
ichthyomorphize again, people who've stopped smoking
are like fish: They tend to want to keep away from the
smell of nicotine. Suntan lotion, scented soaps, insect
repellents—bad stuff on your lures. In fact, fish don't
like the smell of the oil from human skin, and some of
the best fishermen rub chum or fish slime on their hands
before baiting up. As I'm sure you know, one of the
wonders of the sea is that salmon are drawn by scent and
taste back to their natal rivers. Researchers working with
them have found that they won't climb fish ladders that
have had bear paws—or human hands—rinsed in the
water running down the ladders, though tomato juice
and human urine don't bother them. . . .

Here we are at the end of the shoal—see the bell

yonder? No luck today. I'm sorry. I guess you just had to experience what every fisherman must. We'd better head in.

s : Oh, well, it's a fine sight out here. I've never seen Makoniky Head from this angle—look at that wonderful forehead of sandy bluffs! And that long stripe to the right must be Lambert's Cove beach.

f : It is. All right, my friend, bring your line in. I'll get the other one.

s : You mustn't be—hey! Hey! I have one on!

f : Whoops. So have I. . . .

s : This is unbelievable—two boated at once, and when we'd given up.

f : Which shall we throw back?

s : The one you caught, of course.

f : It's bigger.

s : The one you throw back always is—you said it yourself.

f : I can't tell you how many times this has happened to me: Fish all afternoon, give up, and catch one on the final reel-in. Actually I often get fish when I'm bringing a line in during a run. The speeding up of the lure apparently excites an otherwise reluctant blue. . . .

[*On the mooring, cleaning the fish*:] I'm not going to sliver this one, because I plan to bake it whole this time. I'll gut it. . . . It's a male—no roe. Stomach's empty. See how gaunt he is—he's really horny, poor fellow. We have denied him the consummation of his urge to keep the great game of bluefishiness going.

[*At the kitchen counter*:] First, I'll make a julienne of some vegetables—cutting them into thin strips: six scallions, two green peppers, one red pepper, three or

four small carrots, and three or four three-inch lengths of celery stalks; mix in two ripe tomatoes cut into small pieces, and just the nubby tip ends of several branches of young broccoli and cauliflower, the latter diced a bit to make the pieces small; and add generous sprays of parsley and fresh dill. Deep in the hollow of the fish where the guts were I'll lay four anchovies lengthwise, and then stuff in as much of the vegetable mixture as I can and still sew up the belly flaps tight with a needle and thread. I'll melt two sticks of butter and add the juice of two limes. Set the oven at 350°. Next I cut another lime into very thin slices. I lay the fish on a bed of the rest of the vegetables in a baking pan, array the lime slices on the body and its bed, and pour the lime-butter over it all. Salt and pepper. Put it in the oven. The fish is a little more than two inches thick, so it will probably take almost half an hour. Baste now and then. . . . Test with a skewer. Not quite done. The skin apparently slows things down a bit in baking. . . . Now! . . .

s : This tastes so different from the other times. It seems a totally new kind of fish.

f : For reasons we're not quite clear about, I think Barbara and I both prefer broiled bluefish to baked. But I thought we should try a baked blue, because this—it has many variants—is one of the more traditional ways of cooking fish in New England. The overhead broiler is a relatively recent invention.

By the way, now that the fish are going out to spawn, there won't be any point in our trying to catch any till they return. They'll be back in the Sound on August tenth. Save that afternoon.

From THE ODYSSEY: BOOK TWELVE

by Homer
translated by Robert Fitzgerald

 Then Skylla made her strike,
whisking six of my best men from the ship.

I happened to glance aft at ship and oarsmen
and caught sight of their arms and legs, dangling
high overhead. Voices came down to me
in anguish, calling my name for the last time.

A man surfcasting on a point of rock
for bass and mackerel, whipping his long rod
to drop the sinker and the bait far out,
will hook a fish and rip it from the surface
to dangle wriggling through the air:

 so these

were borne aloft in spasms toward the cliff.

August 10

FISHERMAN: I'm going to ask you to wear a life jacket.

STRANGER: What's that about?

FISHERMAN: There'll be some danger out there today.

STRANGER: You must be pulling my leg.

FISHERMAN: You wouldn't know it here in Vineyard Haven harbor, would you? You see, we're on a lee shore. The island is a shield; the bay looks calm. But out there by the tip of East Chop, if you look closely,

you'll see whitecaps. The wind's blowing from the west, up around thirty knots, with higher gusts, and the current is ebbing, running *toward* the west out on the other side of West Chop, against the wind, so we'll have one of those nasty days on the Sound that I remember telling you about once.

s : Isn't it foolish to go out, if it's dangerous?

F : Perverse, perhaps, not necessarily stupid. If we're careful. I promised you the blues would be back today: We'd better go out and see if they are. I went out both on Friday, by the way, and yesterday—nothing. They weren't there. But besides that, I thought you might want to experience a rough day. Of course, if the idea frightens you—

s : It doesn't frighten me if it doesn't frighten you; I trust you. But what's up? Is this some sort of rite of passage a "real" fisherman must go through?

F : I don't think that what I have in mind has anything to do with manhood, if that's what you mean. What I'm thinking of is an illusion that seems to be widely experienced by boat handlers of both sexes who go out fishing in rough waters. If you know what you're doing and are cautious, earning this feeling is probably harmless and can be a source of joy. It's a fleeting illusion that you belong to that hardy race of fisherfolk who for many centuries have risked their lives on the treacherous sea to feed their families. It's a fantasy: You can imagine yourself in the noble company of the down-east sailors who went out, through thick and thin, to Georges Bank. You're flying in the face of the woe of the sea. It *is* an arrant pretense, of course, because the time of ex-

posure and the degree of danger are both strictly limited. This *Spray*, as I've told you, is a sturdy platform in the roughest weather. I've sailed since I was a boy, and I know the power of water, and how to be prudent. Yet this dream of gaining even spurious admission to a sacred company still excites me, whenever the wind blows up.

s : Forgive me for saying so, but that idea sounds a little childish to me.

f : We'll see how you feel about it an hour from now. Here, as we approach Nun Three: Look out there. See the waves running?

s : I do. I do. I see what you mean.

f : I'm going to let you cast with the big beach rod today, so we can keep a decent distance from the rip, which will be horrendous. I'll rig it in here, while we're still under the lee of West Chop, and let you take a few practice casts. I'll put a Hoochie and some pork rind on.

Now. The principle's the same as with the light casting rod, except it's a longer swing and a bigger whip. Cast down wind. Good! Try again.

All right. Let's go.

By the way, you'll get wet. You'll see how well named our craft is. I could lend you some foul-weather gear, but it's cumbersome, and with the fine spray flying you'd get wet under it soon anyway.

s : Gosh, West Chop *is* choppy. This looks like one of the Scottish "roosts" you told me about.

f : I'll stay close inshore. The passage I want to avoid is over the last big jog of the shoal. In these conditions, there's a horrid, short, steep, and sometimes breaking swell along that stretch, which juts out a bit to the

east, into the strongest current. We'll loop around inshore and then cut out across the rip opposite Leroy Goff's house.

s : Hurray!

f : This is nothing. Wait till we go through the rip.

s : I should think this pounding would break *Spray*'s back.

f : Keep a good grip on the handhold up there in the corner of the windscreen. Do you see that there are two kinds of waves? There are long swells, which swoop us relatively slowly up and down; they've come, faster than the weather, from some storm way out in the Atlantic. Then there are these surface waves we're banging on—fierce today because of the long fetch of a strong wind from the open sea straight up Vineyard Sound, against a three-knot current. What's so hard to take in is that the water in the waves isn't moving with the wind, as it seems to be; a copepod—one of those tiny shrimplike plankton I saw under the microscope that day in Woods Hole—a helpless copepod under the surface will oscillate in a big elliptical orbit as each wave form goes by, but it won't move to the east. Only the shape of the wave moves. In fact, the water is actually scurrying *toward* the wind, toward the west, because of the current of the ebbing tide. The copepod will be off Tashmoo in ten minutes. It's that opposition, water versus wind, that makes up this vicious sea.

s : God, it's exciting.

f : Aha! You address the deity.

s : How can I cast from a bronco's back?

f : On the other side of the rip from here, right over the shoal itself, the water rushing over the under-

water dam levels itself out into an apron. You'll see. It won't be smooth, by any means, but it won't be as bad as this. All right, now I'll swing around, and we'll go through the rip with the seas behind us.

s : Oh! Oh! What a ride!

f : There. We planed. Almost like skiing.

s : Coney Island! Shoot-the-chute! . . .

f : Now. You see. This is better. I'll pull away to a safe distance. Take the rod. Plant your feet wide apart. Heave ho. . . . Good cast.

s : Wait a second. I have a fish on. On the first cast!

f : All right. I'll keep pulling away from the rip. Keep tension but don't rush it in—don't "horse it in," as the islanders say—because both the boat and the current are putting pressure on the fish. . . . Hoist it aboard. . . . Fine.

s : I can't get over it. On the first cast.

f : Postcoital gluttony. They're eager now. I'm not even going to try to take it off the hook out here. I'm going to run around under the lee of West Chop. We can talk some in there, maybe go sightseeing up Lagoon Pond. Enough's enough out here today.

Hold on. We'll go straight into the rip this time. . . .

[*Near Nun Three*:] Into the box it goes.

s : That was so exhilarating! I take it back—my skepticism about the rough-water euphoria you spoke of —with apologies. Can I dare say I shared the illusion?

f : If you did.

s : Glory be. You picked me up on speaking to God. I don't happen to be religious, but to pluck a fish out of that wildness . . .

F : Fishing is sacred. It always has been.

S : You used that word before. But wait a minute. How in God's name did you know the blues would be back today?

F : For many years I kept a log of every fish I caught on Middle Ground. I recorded the exact place on the shoal where I caught it—near which of its enduring "holes," numbered in sequence from its eastern end; the size of the fish; the time of day; the phase of the current; the direction of the wind; the state of the weather; and anything else unusual—such as roe showing up, or odd bait in the stomach, scars, sea lice, whatnot. Before long, patterns emerged: of the blues' arrival in the spring and departure in the fall, the midsummer gap while they spawned, and a truly interesting rhythm of catches linked to the phases of the moon.

I could calculate from the tables in *Eldridge's* when the tidal currents would start moving one way or the other out on Middle Ground, and in fact I soon discovered that the changes in direction off the Chop end of Middle Ground roughly coincided with the times of high or low water in Boston Harbor, so I had a quick way of looking them up without doing any figuring. My logs told me, after a few years, that I caught the most blues in the first hour of flooding current; other good times, in descending order, were the last hour of the flood and the last and first hours of the ebb. Best fishing on southwest wind; at dawn and dusk; or, if during the day, under slightly cloudy skies. Wonderful just before a thunderstorm; not too good on a steadily falling barometer; rotten here in the rain. And so on.

But then I began to observe something else much more fascinating. As the moon waxes and wanes, the rise and fall of the tides, too, vary in intensity. The strongest tides, called "spring tides," come twice each month when the sun, the moon, and the earth are almost in line with each other—at full moon and dark of the moon. In Boston Harbor, tides vary with the phases of the moon from spring tides of about eleven feet to "neap tides," the weakest ones, of about eight feet, measured from mean high to mean low water. My logs showed me that I was most apt to catch bluefish on Middle Ground shoal in Vineyard Sound in those times of the month when the rise and fall of tides in Boston Harbor were ten feet or more. In other words, blues were most apt to hit in those times of the month when the currents were running relatively strongly in the Sound, as they would be at the same times in and out of Boston. On the other side of the Vineyard, off Wasque, the experience is just the opposite: better catches come on relatively slack currents. But what struck me as so strange was that it was just that certain cutoff point in the variance of tides at Boston, the ten-foot mark, that determined my "luck" on Middle Ground.

After several years of logging, I noticed something else—that the blues came back in from spawning on or about the day in early August when the ten-foot cutoff was reached. Actually, on what I think of as my end of the shoal, there seemed to be a slight lag: They usually arrived the day *after* the first ten-foot tides in Boston. Notice that I said "usually." There are no rules in fishdom, only likelihoods, which sometimes thin out to bare

possibilities. So I banked on one of them in predicting when the fish would be back, and yes, I was a bit lucky. They turned out to be here.

s : They did indeed. Doesn't sound like luck to me.

f : Most "luck" is having noticed—though it's chancy even then.

s : The first day we came out, you spoke of how you value hours of lonely thought out on the water. You couldn't do much quiet thinking on days like today, could you?

f : No, but you and I have been out days when we glided on glass. And danger doesn't rule out thought.

s : What goes through your mind when it's so foul out there? Sacred company. You used the word sacred. Why?

f : The word comes to mind on rough days. It has a relevant anagram, you know: scared. When a wave is chasing your boat with a breaking crest that is higher than your transom, deep thoughts occur to you. As you've noticed, there's death out here—the death of our catch. Salmon fishermen don't talk of catching fish; they say, "I killed a nine-pounder." I don't think we need feel guilty about the killing we do; we do it for life's sake: our own. But I guess for that very reason the killing may put a scared and thoughtful fisherman in mind of his own span. There's a rather harsh tale of our times in a poem by Robert Lowell about a drunken trout fisherman who, while casting in a stream, vents his rage at aging and the approach of death, and expresses his hope that "when shallow waters peter out" he will be able to "catch Christ with a greased worm" and—by inference —save his soul.

Lowell was a Christian, and he was probably right to resort to the metaphor of fishing for his purpose. Christianity is an aquarium, you know. In the fourth century, the cross was not the prevailing symbol for the Man-Fisher; the fish was. The Greek word for fish, ΙΧΘΥΣ, *ichthys*, was an acronym of the Greek words for "Jesus Christ, God's son, savior." Izaak Walton, the great moralist of fishing, writes that Christ gave precedence among his disciples to the four who were fishermen, Peter, Andrew, James, and John, and that when he rose from the dead and went up on the Mount, he took with him only three, all fishermen. A cichlid in the Sea of Galilee that has a dark spot on each side was thought by early Christians to bear the marks of St. Peter's thumb and finger, placed there when he took a coin from the fish's mouth. In the tenth century fishermen were advised to catch limpets and inscribe on their shells a so-called Gnostic formula, Ιαω Σαβαωθ, "Jehovah, Lord of Hosts," whereupon fish would swarm to them, and the haul would be amazing. In New England folklore, centuries later, the cod was sacred because it was believed (mistakenly, of course) to be what Christ used when he multiplied the fish and fed the multitude. The haddock, on the other hand, was thought to have got its stripes from the devil.

Christians were by no means the first, or the only ones, to have made fishes and fishing sacred. Three kinds of eel in the Nile were hallowed by ancient Egyptians. The Sumerians revered Nanshe, goddess of the craft, who was envisioned as clothed altogether in fishes. The ancient Assyrians worshiped a mermaid goddess named Atargatis, sometimes called Derketo, and the principal

god of the Philistines was named Dagon, "Little Fish." The Hindus' Vishnu sometimes took the form of a goldfish. The dolphin was consecrated to Aphrodite and the tunny to Poseidon, and Venus turned herself and Cupid into fish to get away from the Giants. The lobster was venerated in Seriphos; the crab was deified in Lemnos. In the Talmud the scaled fish is symbolic of innocence. The Japanese picture a traditional fisher god, Ebisu, with a porgy in one hand and a rod in the other, and, to this day, whenever a boy child is born they fly a carp kite from a pole over the house, to assure worldly success. The Hurons married two girls each year to their fishnets, in ceremonies even more solemn than those for the marriage of two human beings, and they made long addresses to the fish to propitiate them.

The first writing in English on fishing for pleasure, *The Treatise of Fishing with an Angle*, is attributed to a legendary nun, Dame Juliana Berners, prioress of the Sopwell Nunnery, who, according to one of several dubious authorities on her authorship, "was a manlike woman endowed with brilliant gifts of nature. She was a Minerva in her studies and a Diana in hunting, lest by pursuing leisure she might be involved in the charms of Venus." The treatise was printed in 1496; it had been written about seventy-five years earlier, and there is a partial copy of it, made by a scribe about 1450, in the Yale library. I like the line the good nun took. She asked: "What are the means and cause to bring a man into a merry spirit?" And her answer was: "They are good and honest sports and games in which a man's heart takes pleasure without any repentance. Then this follows— that good and honorable recreations are the cause of

man's fair old age and long life." How can I, with my white hairs, not like that?

In the century and a half after Dame Juliana and before Izaak Walton, writers on fishing took a high moral line. The anonymous author of *The Arte of Angling*, in 1577, for example, attributed thirteen "gifts" to the fisherman: faith, hope, love, patience, humility, fortitude, learning, liberality, contentment, prayerfulness, fasting, memory, and charity to the sick and poor. And the inimitable Walton, who cribbed from *The Arte* without mentioning it, celebrated the moral superiority of anglers because of their love of "quietnesse and vertue." Byron complained of Walton's air of innocence in writing about a killing sport. And with Hemingway's images, in our time, we come face to face with the underside of "good and honest sports and games": the reeking blood of bulls, the shark-torn carcass of a huge fish.

Fishing is complicated, I keep saying. You've seemed to be asking me in various ways, with various degrees of irony in your questions, whether fishing is, as Walton told us, the contemplative man's pastime. I wouldn't exactly say so, anymore. Times have changed. We're in the twilight of the twentieth century, when greed is the creed. There are assassins out here. Could a contemplative man catch a fish for sport, using its own eye for bait? A sport is defined by its rules. One rule on Middle Ground is that if a boat that is trolling with the current meets a boat that is trolling against it, the former will give way, dropping down into the rip to let the other freely pass. Once, when I was learning how to fish, I overran and cut another man's line when he had a fish on; I hadn't enough experience to know how far a strong

blue could run. That fisherman's tongue polluted the Sound from here to Gay Head! He was right. I had broken the rule—no defense that I had done it in ignorance. Older fishermen on Middle Ground, mostly native islanders, have the basic courtesy to follow the rules of fishing and "rules of the road"—as sailors call navigational rules for safety. But there are many nowadays who tempt a killing of other than fish. Rules? Shit, man, get out of my way, I paid for my gas, up yours, I'm fishing. We can generalize: The bigger and more expensive the fishing boat, the worse the sea manners. You can get skunked out here on any Sunday afternoon on the thirteen gifts of fishermen.

And yet . . . there *is* the magical resonance here in Vineyard Sound of ten-foot tides in Boston Harbor; the high-tech sensitivity of the lateral line; sea clocks of so many kinds; the veliger tucking in its tiny wings when danger comes—such a dizzying wealth of amazing things. And don't forget the superb mechanism we have back there in the fish box, which you caught on a dangerous day. I am not religious, either, Stranger, but sometimes I am tempted to call the bluefish sacred. I almost think it so.

Fishing *is* complicated, isn't it?

s : I think I'm beginning to understand what you mean by that refrain. For one thing, I've sensed how complex your own responses are to things that happen out here; I've seen your delight and, it seems to me, sometimes, your discomfort, your exhilaration and your doubt, your warning against applying human terms and values to fishes yet doing it all the time, and your being unafraid and also scared. Am I right?

F : I refuse to answer on the ground that it might incriminate me.

[*At home, in the kitchen*:] I'm going to grill these fillets. I'll skin them and put them in a baking pan and squeeze the juice of a lemon and scatter a pressed clove of garlic on the "meat" side—the innards side—of each one; then we'll let it marinate for half an hour, while we get the charcoal burning in the hibachi.

A beer? You can tell Barbara about what we pretended out there today . . .

Now melt a stick of butter. Spread out a sheet of heavy-duty aluminum foil large enough to take both fillets, and using a pointed knife or an ice pick, prick a large number of holes in the foil. Then butter the foil and brush a bit of the melted butter on the fillets. Put them, meat side down, on the foil, and the foil on the grille. Spoon some melted butter on the fillets from time to time. The point of all this is that if you just put the bare flesh on the grille, it will flake and stick to the hot metal and break up; this way you'll keep the integrity of the fillets and, thanks to the holes in the foil, the flavor of the dripped and burned butter will enhance the taste of the bluefish.

Charcoal's so hot that I'll skimp on the ten-minute rule. . . . Test. Done! . . . Please pass the salt and pepper.

s : It comes out a bit drier than with your other ways of cooking, doesn't it?

F : You can't have everything. You can't have idle daydreams on a rough day.

s : Oh, but it's good.

F : So was the day, wasn't it?

s : I'll never forget it.

THE DRUNKEN FISHERMAN

by Robert Lowell

Wallowing in this bloody sty,
I cast for fish that pleased my eye
(Truly Jehovah's bow suspends
No pots of gold to weight its ends);
Only the blood-mouthed rainbow trout
Rose to my bait. They flopped about
My canvas creel until the moth
Corrupted its unstable cloth.

A calendar to tell the day;
A handkerchief to wave away
The gnats; a couch unstuffed with storm
Pouching a bottle in one arm;
A whiskey bottle full of worms;
And bedroom slacks: are these fit terms
To mete the worm whose molten rage
Boils in the belly of old age?

Once fishing was a rabbit's foot—
O wind blow cold, O wind blow hot,
Let suns stay in or suns step out:
Life danced a jig on the sperm-whale's spout—
The fisher's fluent and obscene
Catches kept his conscience clean.
Children, the raging memory drools
Over the glory of past pools.

New the hot river, ebbing, hauls
Its bloody water into holes;

A grain of sand inside my shoe
Mimics the moon that might undo
Man and Creation too; remorse,
Stinking, has puddled up its source;
Here tantrums thrash to a whale's rage.
This is the pot-hole of old age.

Is there no way to cast my hook
Out of this dynamited brook?
The Fisher's sons must cast about
When shallow waters peter out.
I will catch Christ with a greased worm,
And when the Prince of Darkness stalks
My bloodstream to its Stygian term . . .
On water the Man-Fisher walks.

August 14

FISHERMAN: I brought along some frozen squid for bait. We'll have half an hour of slack tide, before the current starts to flood, and I thought we could while it away with some bottom fishing in the bay, just for a change.

STRANGER: What do we catch?

FISHERMAN: We never know what we'll catch till we've caught it—which puts us in a fix a little like that of the old lady E. M. Forster wrote about, who said, "How can I tell what I think until I hear what I've said?"

STRANGER: Will we catch Picasso fish?

F : No, there wouldn't be any flounder or fluke inside the Chop. There'll be little fishes in here, if we catch any, small sweepers of the floor of the sea. Let's try our luck near Nun Three.

S : Luck? It hasn't looked to me as if you rely too much on luck.

F : Well, I'll admit I've found a few breakfasts around the skirts of my friend the nun. I'll bait up this little bottom rig. Now. Let it run out till it hits bottom. Then just wait.

S : Oh, right away! A delicate trembling on the line.

F : That would be scup. Some people call them porgies—not to be confused with the blues' favorite food, menhaden, or pogies. Scup are pickpockets; they'll mumble your bait cleanly off the hook while you're thinking about what a nice breakfast they'll make. No, don't jerk like that. You have to let the little criminal make a mistake and run off with hook and all, then cop it, keeping cool, as if you'd taken out a warrant. . . . There! . . .

S : That was a spunky little perpetrator.

F : I'll put it in the bucket; later I'll clean it, and you can take it home for breakfast tomorrow morning. Dredge it in flour and pan fry it three minutes on each side, with a little lemon juice and rosemary in the butter. Tasty. . . . All right, let's try again.

S : Whew. I'm so glad to be out on the water. This muggy weather gets me down.

F : August doldrums. We might get some fog later on, if the breeze drops, because the air is so much hotter than the water. On a day like this I like to run a check on my ship-to-shore. Excuse me a minute.

[*Fisherman speaks into radio microphone*:] Coast Guard. Coast Guard. This is yacht *Spray*.

VOICE: Woods Hole Coast Guard Station. Come in, *Spray*.

F: Yacht *Spray*. Radio check, please.

VOICE: Roger. I read you loud and clear.

F: Thank you. Over and out.

S: That was easy.

F: Maybe you think I should apologize for calling this fat little boat a yacht. That's just regulation ship-to-shore chatter.

S: Have you ever had to use your radio for real?

F: I've been towed in several times. Engines are fickle friends. A cracked distributor, a ruptured hose—anchor and call for help.

S: There, that's a stronger bite. It's on, too.

F: Good. . . . That's a young tautog, or blackfish. Makes splendid chowder. Mind if I keep it?

S: Not at all. I wouldn't know what to do with it.

F: There's your bait. Try again.

S: I'm amazed. It's just as much fun to catch little fish as big ones.

F: Ah, now you're saying that fishing is "fun." But what you say is true. I went out once for bluefin tuna, out of Wedgeport, at the southern end of Nova Scotia. My son Martin, who was then about twelve, had a six-hundred-pounder on the line; a shark took a seventy-five-pound bite out of its belly before we could get it into the boat. The young man and the sea!

S: That's the kind of fishing I despise.

F: You anticipate me. I was about to say, catching tiny snapper blues eight inches long for breakfast is more

satisfying for me than that kind of fishing could ever be. Snappers have all the courage and fight of their big brothers and sisters. The baby bluefish usually come in here about August fifteenth—that would be tomorrow. We'll try for them in a few days.

s : Another bite. Feels like another of those blackfish. . . . Good Lord, what's *that*?

F [*laughing*]: You've caught a sea robin.

s : That's the worst-looking animal I've ever seen. It looks prehistoric. Side fins like wings. And what kind of an excuse for a head is that? It looks like a box to keep paper clips in. And holy smoke, it's got six little *legs*.

F : They aren't exactly legs, though they do use them to crawl on the bottom. They're independent spikes of its pectoral fins.

s : Is that *it*, making that horrible grunting sound?

F : Yes, it's a talker. It makes that noise by vibrating some muscles that are attached to its air bladder.

s : What's it saying?

F : It's saying, "Throw me back before you throw up."

s : With pleasure. And just in time.

F : The current's making up. Let's go out and harvest our supper.

s : Yes, please, back to normalcy.

F [*approaching the hole off Goff's house*]: We're in luck. See that broad place over there on the water where it seems oil has spilled?

s : Someone with a bad engine-oil leak?

F : Not if it's what I think it is. Let me get over there, downwind of it. . . . Sniff. What do you smell?

s : Hm. I'd say it smells like a fresh-cut watermelon.

f : That's exactly what I would say. We call it a slick. A school of blues has been feeding and cutting up so much fat bait that the oil and other liquids from the victims have surfaced to make that smooth skin on the water, shiny and pearly as the inside of an oyster shell, which the breeze can't ruffle. The melon smell comes from the fruity odor of the plankton the bait has fed on.

s : You said the first day that some people think bluefish tastes oily. Is it part of a taste chain, an odor chain?

f : I guess you might say so. The blues are oily because pogies and silversides are, and they are because the plankton they eat are. You remember about the oil fields.

s : Would the chain extend on from us? Would we taste oily to a lion or tiger, after we'd eaten blues?

f : Maybe. I don't know that that's ever been tested.

s : You said we're in luck because of the slick. Does it mean the blues are right under it?

f : Probably not. That chopping took place a few minutes ago. The school will have moved on. But it means they're around. The most ferocious phase of their feeding may be over by now, but there's a good chance, on account of their inability to turn off the feeding response, that we'll be able to attract one or two of them. The current isn't strong yet. Would you like to cast?

s : Yes!

f : I'll put the Pencil Popper on—it worked for us that other time.

s [*casting*] : I can't get those surly growls of the sea robin out of my mind. Can blues communicate somehow

under water? I've heard a recording of whales singing to each other.

F : Poets may sing of the silent sea. It isn't. Far from it. Water conducts sound much more efficiently than air does, and the oceans are alive not only with plankton but also with racket. To begin with, there are the sounds of the transactions of the water itself, the electric fizzle of combing waves, the fracture of breakers, the brabble of wash on the shore. At anchor in deep darkness at night I've heard—up where I live, here in the air, but the sound is under water, too—the rip along Middle Ground chattering as loud as a flock of starlings. Then there are the noises *we* make, and very strange they seem, as if there were a translation for alien ears that goes on just beneath surface tension. A distant outboard motor sounds under water like a spoon being tinkled on a plate. Then, creatures talking. You heard the sea robin. There's a whole family of fishes called grunts. Toad-fishes burp the songs of their eponyms; one sort of toad-fish is called the singing midshipman. In the spring of 1942, the navy hydrophone network that had been set up to detect enemy ships or submarines at the mouth of the Chesapeake was jammed each evening by a shattering interference, described as the noise of "a pneumatic drill tearing up pavement"; it turned out to be the uproar of crowds of conversational fish called croakers—a noise that engineers were eventually able to filter out of the sound systems. You must be aware of the eagerness of dolphins to break through the language barrier and give human beings advice on how to live more playful lives. Barbara can't stand the sounds of whale songs because they seem to her so dreadfully mournful; I say, who

knows, whales may moan when they're happy and giggle when they're sad. Several kinds of fishes—carp, chub, barbel, loaches, and others—release gas bubbles from their air bladders through ducts into their guts, and when they do, they squeak like mice. Among many other fish sounds are tomtom bumps, chicken clucks, dog barks, foghorn moans, wrestlers' grunts, and the noise made by a wet finger rubbed on a balloon. Oyster beds rattle. In many places there is a sizzling sound, like that of bacon frying, or that of a short circuit, made by myriads of a small variety of shrimp clicking their claw joints. Once the *Atlantis*, the research vessel of the Woods Hole Oceanographic Institution, lowered a hydrophone into very deep waters near Bermuda and picked up weird cat's mews, shrieks, and groans, like those on the sound tracks of a horror movie, which have never been accounted for. Fish make sounds just by moving through the water—veering, streaming, flexing their tails. Ghanaians fishing for herring and other fishes lower a three-pronged paddle into the water, rotate it slowly, hold an ear to the upper end, and listen for the direction and distance from them of the swimming sounds of schools.

We have it on the authority of Aristotle that fishes can hear, "for they are observed to run away from any loud noises like the rowing of a galley." Once, on a sailing trip down the Windward Islands, I saw men and women out at dawn, hip deep in shallows under the lee of Pigeon Island, off the northern tip of St. Lucia, beating the water with long poles to drive fish toward their seines, and I've read that English fishermen, working from the ports of Whitby and Scarborough, fishing with deep nets, used to drive herring down into them from

the surface by banging on the sides of their vessels with shovels, buckets, and tin cans.

Bluefish have—

s : *I have a bluefish!* It feels like a big one.

f : They're still famished after their spawning expedition. Their hunger makes them extra vigorous. . . . Yes, it's one of our standard five-pounders. . . .

By the way: Twice, now, you have shown signs that you were being won over to angling, when you asked me if you could catch just one more, to throw back into the sea after you'd caught it. Do you want to do that today?

s : I don't know whether I'm being "won over." I've certainly been made aware—by you—of the many riddles in the experience of fishing. But to give an honest answer to your question: Yes, I'd love to try for another one!

f : Fine. I'll change lures. . . .

s [*casting*]: But go on. You were getting to the part about bluefish and hearing.

f : Bluefish don't have external ears, of course, but like other jawed fishes they have pairs of sinuous labyrinths, tiny spelunker's mazes, inside their heads, forward of the gill covers, with three little chambers on either side, each containing a minuscule calcified ear stone, the rattlings of which tap sound codes into sensory hair-cells. The uppermost of the three chambers is a kind of gyroscope, registering yawing, pitching, and rolling movements, so the fish can always be in full control of its place in its fields of vision and action. The other two chambers are for hearing. Some kinds of fishes have a direct linkage between their ears and their air bladders, which latter serve, drumlike, to amplify sounds; the blue-

fish isn't one of these, but its air bladder probably does have some indirect effect on its hearing. Researchers using that tank at Sandy Hook found that blues can hear in a range—much less than ours, but sufficient to their needs—of from less than one hundred to about three thousand five hundred cycles per second.

Now, you asked whether blues can communicate with each other. Not in the sense of conversing. They don't utter intelligible sounds, in our terms. But they are certainly in touch with each other. The combination of their hearing and their lateral-line sense makes them keenly aware of where they are in relation to each other, whether schooling or not. If Ghanaians can hear swimming sounds, so can they. Besides keeping track of each other, they can pick up the water sounds made by a school of bait, and move toward it, and so violent is their chopping of their victims when they reach it that the gnashing and clashing of their teeth are both directly transmitted through the water and also resonated in their swim bladders, and are thus doubly drummed out in helpful broadcasts to other ever-hungry blues.

Of course, they can hear *Spray*'s propellor. And, since we catch them while trolling, you might think it doesn't alarm them. But that's probably just another example of the irresistible power of their feeding response. The sound eventually gets to them. I've found that it's no use running back and forth more than two or three times over a hole where you know they have been.

Blues' aural communication, such as it is, is coordinated with other kinds of message giving. You remember the inflamed spot by the pectoral fin at spawning time, and the flashing pelvic fins while they were feeding in

the tank. And they see and respond to each other in schooling.

s : You've talked a lot about the air bladder. Would you—oh-oh. Hold it. Fish! . . .

f : Nice work. . . . Back it goes. By the way, there comes a fog bank, up the Sound. The breeze must be dropping.

s : Should we go in before it gets to us?

f : We don't need to hurry. The rip of the shoal is a perfect navigational guide, slanting in toward the tip of the Chop.

You were asking about the air bladder. This organ gives fishes in water what the astronauts have in the upper air—weightlessness. Without it—and, in that case, without constant motion and constant expenditure of energy—they would sink to the bottom. Scuba divers achieve weightlessness under water with the help of buoyancy compensators, which are, in effect, air bladders worn outside instead of inside. The fish's bladder is a gas-filled sac in the upper part of its hull, just below the backbone and kidneys. In some primitive fishes this bladder evolved into a kind of Aqua-lung, for air breathing if they lived in oxygen-poor water or in rivers that dried up at times. In most bony fishes it is solely a hydro-static device. Blues have closed, self-contained air bladders. Large, specialized cells within the sac generate gases, mainly nitrogen, oxygen, and carbon dioxide, which inflate the little balloon.

Water pressure increases with depth. At the surface, water pressure is equal to air pressure; about thirty feet down, it is twice that. You've heard of tunnel diggers getting the bends from too rapid changes of pressure

when they surface. Blues have to contend with that same problem. When they stop feeding at the surface along Middle Ground and go to the bottom to leeward of the shoal, their air bladders are compressed to half the size they had at the surface, and they become heavier than water—or they would, except that the specialized cells pump in additional gas to restore buoyancy. Then, ascending, the bladder swells and needs relief. Blues, with closed air bladders, aren't able, like the fishes I mentioned earlier, to fart out surplus gas with mousy squeaks. Instead, part of the bladder wall has a dense network of capillaries which enable the blood to absorb the excess gas rapidly. Thus the air bladder serves to maintain constant buoyancy in the blue, much as the trimming tanks do in a submarine. Man's first working submarine was a wooden craft with a greased leather skin three hundred fifty years ago; fish have had swim bladders for millions of years.

s : In other words, Fisherman, Nature's a jump ahead of you and me.

f : Many a jump, Stranger.

Here's the fog. Like a wall of steam. Now you see the Chop . . . now you don't.

s : It's like being in a small room.

f : Which direction is West Chop from here?

s : I've forgotten! I'm lost!

f : No you're not. We have the rip.

We were talking about sound under water. A fog seems to bring the world to your window. I'll turn the engine off. Hear that thumping? It sounds fifty feet away. That's the *Islander*, the Woods Hole–Vineyard Haven ferry, just turning out of the Woods Hole chan-

nel. Listen! Hear that bell? That's at the other end of Middle Ground, three miles away.

s : I hear it. "Full fathom five . . ." Sea-nymphs ringing my father's knell.

f : Yes, that's apt: there are ghosts and spirits in any fog. I think I know what I'm doing, but I still get the shivers when I'm alone in a fog out here. Let's mosey in. I'll follow the rip till its last jog, then turn southeast until I see shore—there's plenty of water right up to within ten feet of this side of the point. There it is.

s : How huge the Chop looks. Surprisingly swollen, like the just risen moon.

f : Now I steer one hundred degrees by the compass for six minutes. . . . One hundred twenty-five for ten minutes—have to take a wide berth here, there are rocks inside the tip. . . . Then—but it's clear in here, as it so often remains between the Chops, when the wind is out of any southerly quarter. . . .

[*In the kitchen*:] Tonight we're going to Italy, via the palate. Barbara and I spent a year there and yearn to go back. I'm going to coat the fillet with pesto—pesto, that is, minus Parmesan cheese, which is death to bluefish. I whirl up three not-too-tightly filled cups of basil leaves, three cloves of garlic, three-quarters of a teaspoon of salt, and two tablespoons of pine nuts—you can get them at the health-food store on Beach Road—in the food processor. All right, it's pasty. I'll blend in a half cup of olive oil. Presto! Pesto.

Skin the fillet. Use olive oil to grease the broiling pan, and brush a thin coat of it on the meat side of the fillet to keep it from getting too dry. Broil close to the flame; Canadian rule. . . . Soft all the way through—

spread about three tablespoons of the pesto on the fillet (I'll freeze the rest, with a thin skin of olive oil on top). Put it back in the broiler for just a minute, till the sauce bubbles but not till it browns. . . . *Pronto!*

s : *Viv' il pesce azzurro!*

f : *Viv' il nostro lavoro!*

SONG

by William Shakespeare

Full fathom five thy father lies;
 Of his bones are coral made,
Those are pearls that were his eyes.
 Nothing of him that doth fade
But doth suffer a sea change
Into something rich and strange.
Sea-nymphs hourly ring his knell.
 Ding-dong.
 Hark! Now I hear them,
 Ding-dong bell!

August 20

FISHERMAN: Let's see on the way out whether we can fish for snappers today.

STRANGER: Where do you look for them?

FISHERMAN: Do you see that brief surprise of totally green real estate on the near side of the tip of the Chop, where houseless meadows meander down to the sea? See, off it, those two tall piles someone put out in the water long ago, to pulley-moor dories with? Snapper blues hold a convention just there, starting each summer in mid-August.

s : Why there?

f : It's a spa for baby blues. First of all, it's shallow, about eight to ten feet deep; the water's warmish. Because of the shelter of the point, the currents eddy weakly there, yet the home fluid keeps moving. The bottom is rocky, and there are tall wavy weeds for them to hide in.

Yes. They're there. We can try for them.

s : How in the world can you tell? We must still be a quarter of a mile away.

f : See those little specks of birds flying back and forth a few inches off the water? Those are laughing gulls, and every summer, as soon as the snappers foregather, they start skimming around, waiting for schools of the baby blues to drive schools of whitebait up to dimple the surface, setting the table for the gulls' lunch. Wings announce the presence of fins.

Steer for the pilings a minute. I'll rig the rod. . . .

Here we are. We can just idle the engine and drift.

s : What a lovely, slender rod—like a swift line drawn by a quill pen.

f : Isn't it a beauty? That rod belonged to Dashiell Hammett. Lillian Hellman gave it to me. I always hope I can catch a good plot with it. I've rigged it with the lightest of lines, spun by a monofilament spider. On it we put this tiny, silvery Kastmaster, which swims like wounded whitebait. I should warn you that when you cast you must snap the bail and start reeling the moment the lure hits the water; otherwise it'll sink and get caught in the weeds. Try a cast. Just a sharp flick of the wrist . . . and, yes!—out it goes for a hundred feet! Nice!

s : How big will the snappers be?

f : How small, you mean. Five to seven inches, now.

s : How could they be that big? You said the blues had come in from their spawning just the other day.

f : Some marine biologists have speculated that there may be two distinct genetic stocks of bluefish off our east coast, one of which spawns off the Carolinas in the spring, the other in summer months in the so-called Middle Atlantic Bight, within the great curve of the shore from New Jersey to Massachusetts. One observer thought he found consistent differences between the two breeds of blues—analogous to the differences, I guess, between southern and northern writers. The southerners were said to have slightly larger heads, bigger eyes in proportion to their heads, longer upper jaws, and differences in various fin lengths from those of their northern cousins. (I think it's the size of the head that counts with writers.) In any case, the northern stock goes out to spawn in relays from early July to early August, and I presume that the snappers that show up hereabouts in mid-August—these right here—are small fry of some early July spawning by blues somewhere along the coast between New Jersey and here.

s : That might be a long voyage, coming here. How do those tiny things make it?

f : I have to warn you, first of all, that everything I can say about the blues' spawning is iffy. It's mostly guesswork. There's pretty good evidence that their spawning takes place out on the edge of the continental shelf—the place where the bottom drops off to the abyss.

That means our friends swim from thirty to a hundred miles out to sea for sex.

s : No wonder they're hungry when they get back!

f : No wonder. Anyway, their offspring are pelagic plankton at first—drifters on the surface, that is—and it's thought that the larvae and small fry probably ride the inner edge of the Gulf Stream awhile and then are swept shoreward by eddies of the Stream and by various onsetting currents. (These currents have been found to exist by oceanographers who dropped tens of thousands of marked bottles in the sea and then kept records of where they fetched up.) In time the little snappers swim into the shallows of estuaries along the coast, and to warm-water hotels like this one under the jaw of the Vineyard. They grow here very fast, preparing for the great migration southward in the fall.

Look over the side. You can see a cloud of them, maybe ten feet across—hundreds of them in a tight school. Those are the babies. If there are tailors around, one-year-olds, they'll school separately. Smaller with smaller, bigger with bigger. Birds of a feather. This is partly a matter of safety—the big will eat the small—and partly a matter of energetics, because the swimming speed of a twelve-inch blue is much faster than that of a seven-inch blue, and of a twelve-pound blue very much faster than of a seven-pound blue. It costs smaller fish too much energy to keep up with their seniors. There's a hydrodynamic advantage to schooling, too—the leading fish penetrate the water envelope and make it easier for the following ones to move through it; but there is an offsetting disadvantage, in that oxygen is depleted in the middle of the school. As the school veers, followers take

their turns at leading, so that energy remains fairly distributed. Blues form a very tight pod when they're threatened and frightened, but when food presents itself, they'll break up and free-lance, one by one.

s : Wait! I've hooked one! How right you were: With this delicate rod and light line, it's as if I were wrestling with Leviathan.

f : They're feisty, aren't they? . . . I'll get it off the hook and drop it right in the bucket. Notice that it's a little deeper in the hull and flatter than the adult blue.

s : But go on about spawning. What happens in their courting and mating?

f : No one knows. Up until now, no scientist has ever surprised blues in the primal scene. Guesswork: Aristotle asserted that female fish swallow the males' sperm and thus conceive. It takes a first-rate male philosopher to dream up pregnancy via fellatio. Of course that won't wash. I can tell you about the habits of three species other than blues, which *have* been watched in the act by scientific voyeurs, and the only assurance I can give you is that these types' sex habits are bound to be different from those of our friends.

One of the most fascinating fishes, when it comes to propagation, is the little stickleback, a prickly specimen which seldom grows to more than three inches long. At courting time, the male, decked out in brilliant nuptial colors, stakes out a territory among weeds in brackish water, and if any other well-dressed male comes around his keep, he darts at it with his jaws open, as if to dine, and drives the trespasser away. He now builds a nest, a kind of tunnel with a round sandy floor and walls and ceiling of stems gummed together with the slimy mucus

from his flanks. By this time his dress has become even more brilliant than before: its reds more penetrating, its black cells contracted to minute stippling, and bluish crystals sparkling through the skin from beneath. A female, a silvery roly-poly Rubens figure, approaches. The gorgeous male does a dance of loops and zigs around her, and then begins nudging her toward the nest, nipping at her fins if she tries to turn away. She enters the tunnel, with her head and tail sticking out at the ends. The male butts her tail repeatedly with his snout, and she deposits her eggs. Then this feminist fish leaves the nest, never to return. The male enters at once and pours his milt over the eggs, and exits. Next, polygamist that he is, he flags down two or three more females, in sequence, and jigs them into his lair. One by one, the feminist dames beat it. For seven or eight days the male fans water over the eggs to aerate them. When they hatch, child care is all his. He guards the brood and keeps them tightly together, training them to school. If some wander, he takes them in his mouth and spits them back into the crowd. In time, when they have graduated from kindergarten and are used to school, the father suddenly gets bored and pallid, and goes off to join the grown-ups—perhaps to find out what the women are talking about now.

[*Stranger catches another snapper. It is lodged in the bucket. As is his habit, the Fisherman keeps right on talking.*]

Then there's the dogfish. It's a small shark, two to three feet long. I catch one of the nasty things around here, once in a while, when I'm bottom fishing for fluke and flounder. They're harmless; just ugly—though not

necessarily so, of course, to each other. Like other sharks, dogfish copulate. The eggs are fertilized inside the female. The male has a pair of sexual organs called claspers, and to inseminate his partner he coils himself around the waist of the female, his claspers inserted in her cloaca, in an embrace which appears to an anthropomorphizing human observer to be delightful; his sharky head declines sidewise toward the female's torso, with the underface turned up and the mouth drawn back in a lascivious grin.

With the sex habits of the codfish, we may be coming a little closer to those of the bluefish—though in fact we have no way of knowing for sure. As the spawning time approaches, the male cod becomes aggressive, and he creates a watery sphere of territory around his own body —a territory that moves with him as he swims. He will not let other males or unripe females inside this bubble of his authority, and gradually, after numerous encounters of colliding territories, there emerges a bullying order of males, one which may help to ensure that vigor is perpetuated in the race of cod. In time a ripe female, gliding with easy assurance, enters a dominant male's bowl of space. The male, seeing her, raises his dorsal fins for a moment, and then approaches her. He faces her, about a foot away, and begins a dance of veils. All his median fins are fully erect but loose at their hinges, and as he lithely bends his body back and forth, they wave their invitations, and meanwhile he alluringly opens and closes the fans of his dorsal and first ventral fins. He turns. She follows him. Now he wants to persuade her to go up to the surface—for the fertilized eggs will only be able to survive as plankton on the skin of the sea. He

continues his display, he grunts (as cod can do), and he nudges her ever upward. During all his nervous flashing, she moves smoothly and calmly, taking her time. When they reach the surface, he suddenly swims over her, slides down one side of her, and turns upside down, belly to belly with her, clasping her with his pelvic fins, their genital openings pressed one to the other. She emits her eggs, he his milt. The female swims out of the male's ball of fire and joins other cod. He is still hot and charges intruders, uttering threats.

s : How great. There seems to be wonderful enjoyment.

f : You could certainly call it, anyway, a very strong urge.

s : And rituals, all through nature.

f : It appears so to us.

s : But fish squirting eggs and milt into the huge wet sea doesn't seem a very efficient way of achieving fertilization.

f : Well, sperm have little tails and can swim, you know, and they're attracted to the eggs by chemical messages the egg membranes broadcast in the water.

[*Stranger catches a big little one.*]

s : How long does it take for the eggs to hatch?

f : Bluefish eggs have been caught in the wild and hatched in captivity. They are about one twenty-fifth of an inch in diameter; they have a transparent outer membrane and a colored yolk, and they contain a single globule of oil one eight-thousandth of an inch in diameter. (Remember the oil fields?) They hatch, out at sea, in a couple of days, in water at about 68° Fahrenheit, still attached to the yolk sac. They hover upside down

at first, near the surface of the water, floating at an angle with head higher than tail. In three or four days they have absorbed the yolk and are righted and trimmed up to an even keel. They are now about an eighth of an inch long. Weak swimmers at this stage—O Lord, thy sea is so big and my vessel is so small—they wiggle their tiny rudders in short bursts but soon give up, each time, and let themselves be transported in the great northerly drift. [*Stranger brings in another snapper*.] Feeding on plankton, the little blues grow very fast. When they first arrive in northern estuaries, in the middle of June, they are about two to three inches long—"critters so small," as Joe Allen once put it, "that it would take fourteen to make a dozen." By late July, they're three or four inches long, by the first week in August, four or five inches, and by mid-August, when they arrive here, from heaven knows where, they've grown, as you've seen, to five to seven inches long. I catch them here through September, when they're seven to nine inches long, and by the time they leave in mid-October, they are eight to ten inches long.

The speed and relentlessness of the blues' growth—in size and ferocity—is more than impressive; it's appalling, hair-raising. Ted Hughes has a poem about the somewhat similarly startling stages of life of another murderous fish, the pike; I'll try to find it this evening.

I should have said, those bluefish that survive grow fast. From the very first, from the moment the mother gives her million eggs to the sea, these creatures are mere numbers in Nature's megadeaths lottery. Sudden changes in water temperature; plankton that eat plankton; carnivores of many sorts, from gemlike jellyfish to bloated

bluefin tuna; quirky currents; mankind's pollutants; birds with laser eyes; gluttonous and fratricidal blues; and you, Stranger, Thin Man, with your deadly quill-stroke rod —so many hazards! It's a probability that from a spawn of a million eggs, no more than two or three bluefish survive to maturity. A delicate balance!

[*Stranger hooks another snapper. At first he plays it as he had the others, but then*:]

s : Look at that one run! It's suddenly ten times stronger than it was at first. Can I put more drag on?

f : No! The line will break. You've probably caught a tailor. A year-old fish has eaten the snapper you had on the hook, and now *it*'s hooked. Big brother. This is what I was talking about—two more numbers lose in the lottery, one gobbled, one hooked. You're going to have to be patient, with that gossamer line. I'll move the boat to follow the runs. Reel in when you can. . . . I'll net it. . . .

s : That was thrilling. I'm afraid I *am* being won over. How much would you say it weighs?

f : Maybe a pound, pound and a half. It'll be delicious. . . . Shall we call it a day?

s : All right. . . . I'm haunted by the lovemaking of those three kinds of fish you were telling about. I know that to call it that is anthropomorphic thinking, but I can't help it. I found it charming.

f : That's natural. As long as there have been fisherpersons—and there have been those since prehistoric times, as the fish skeletons in the middens in the caves of France testify—as long as human beings have gone fishing, they've associated fishes and fishing with sex. This may be because the fluids of human sex, if left

unwashed, smell fishy. Whatever the reason, the dream has certainly gone deep. In ancient India the fish was a symbol of progenitive power. Plutarch writes that when Osiris was killed by Typhon, Isis searched everywhere for his remains, but she never found his penis, which had been thrown into the Nile and had been eaten by the eels, which thenceforth were sacred; she erected an obelisk to consecrate the lost and mourned phallus. Greek fishermen worshiped four gods: Poseidon, god of the sea; Hermes, because he was crafty; Pan, the goaty, sexy one, as deity of the animals of both land and sea; and Priapus, the god of horniness. Cupid is sometimes pictured holding a rose and a fish—ironic symbols of love, both prickly, one short-lived, the other untamable. In that fishing town Naples, to this day, *pesce* is dialect for the male organ.

You thought those three kinds of fish sexy? Walton quotes some lines from a poem about the creation of the world, written in 1579 by Guillaume de Salluste du Bartas:

> The Adult'rous Sargus doth not only change
> Wives every day in the deep streams, but (strange)
> As if the honey of Sea-love delight
> Could not suffice his ranging appetite,
> Goes courting She-Goats on the grassie shore,
> Horning their husbands that had horns before.

Fish have been called into court in cases of human adultery. In Greece and Rome an adulterous woman was punished by having a mullet inserted in her vagina.

s : How disgusting. What was done to philandering men?

F : In those days? It was always the woman's fault then, of course. I remember once in Paris, going after a long night of partying for a dawn brandy to a bar beside the great produce market Les Halles, where farmers who had brought their vegetables to the city were having one for the road home; and there was a man with a drawing of a fish pinned without his knowing it to the back of his dirty white tunic, to announce to the world that he was a cuckold. His friends were all drinking to him and clapping him on the shoulders, and he seemed a little puzzled by his sudden popularity and celebrity.

Some Greek and Roman writers—Epicharmus, Varro, Plautus—considered fish aphrodisiac, required eating at wedding feasts. And maybe you remember how fish figured in foreplay in Cleopatra's seduction of Antony. While they were fishing together from her barge, they bet on their catches, and Antony, thinking it would excite her, had some of his men dive and attach a live fish to her line. But she was wise to him, and she then had a diver hook a salt fish to *his* line. Plutarch told the yarn first, Beaumont and Fletcher picked it up, and then Shakespeare let us see what this fishy flirtation led to, as Cleopatra's handmaiden Charmian, in Antony's absence, recalled it to her. Whereupon the queen said:

> That time—O times!—
> I laugh'd him out of patience; and that night
> I laugh'd him into patience: and next morn,
> Ere the ninth hour, I drunk him to his bed.

[*At the mooring*:] I'll clean the snappers with a pair of scissors—inserting a blade in the anus, cutting forward to the forepart of the belly, then snipping the head, fins,

and tail off. The guts slide out, and I trim them off. Simple. Have two for breakfast. May I have two? (Barbara doesn't like fish in the morning.) Pan fry them. These are very sweet and need no herbs, though a sprig of fresh dill can't hurt. I also like them with a bit of rosemary.

Now I'll clean the tailor in the regular way.

Just for curiosity, let's open both a snapper's and the tailor's stomachs, to see what they've been eating. . . . Those are gobbets of bluefish flesh in both bellies. Cruel lottery, isn't it?

s : They'll be in our bellies before long.

f : True.

[*In the kitchen*:] Tonight I'll trim off the tops of the stalks of a bulb of fennel—and here's a bit of outside rib that's a bit tough; that I'll cut away. Now, cutting down from the top, I'll slice it into three-quarter-inch strips. I put them in this skillet, which is big enough so the strips can lie more or less in a single layer. I add a tablespoon of butter, a little salt, and three-quarters of a cup of water. I cover it over and cook gently for ten or fifteen minutes. . . . I must check once in a while to make sure that the fennel isn't burning on the bottom and that the pan hasn't gone dry. . . . Oops, it needs a little more water. . . . Now the fennel's tender. I make a bed of it on the bottom of this broiling pan and put the fillets on it. Salt and pepper, and dots of butter on the fillets. Then broil, with the rack on the topmost rests. These two small fillets won't take more than six or seven minutes. Now I'll sprinkle a half teaspoon of fennel seeds on them and put them in for another minute to brown the seeds. Then on the plates with a garnish of some of the feathery tops

of the fennel, chopped up, and with wedges of lemon.
Shall we try it?

s : This is superb!

f : Be careful. You'll inflate me with hubris.

> I am in truth a God, I bring the dead
> By mere scent of my food, to life again.

s : I wasn't dead, sir. But I admit I hadn't lived, till
I tasted this.

PIKE

by Ted Hughes

Pike, three inches long, perfect
Pike in all parts, green tigering the gold.
Killers from the egg: the malevolent aged grin.
They dance on the surface among the flies.

Or move, stunned by their own grandeur,
Over a bed of emerald, silhouette
Of submarine delicacy and horror.
A hundred feet long in their world.

In ponds, under the heat-struck lily pads—
Gloom of their stillness:
Logged on last year's black leaves, watching upwards.
Or hung in an amber cavern of weeds

The jaws' hooked clamp and fangs
Not to be changed at this date;
A life subdued to its instrument;
The gills kneading quietly, and the pectorals.

Three we kept behind glass,
Jungled in weed: three inches, four,
And four and a half: fed fry to them—
Suddenly there were two. Finally one.

With a sag belly and the grin it was born with.
And indeed they spare nobody.
Two, six pounds each, over two feet long,
High and dry and dead in the willow-herb—

One jammed past its gills down the other's gullet:
The outside eye stared: as a vice locks—
The same iron in this eye
Though its film shrank in death.

A pond I fished, fifty yards across,
Whose lilies and muscular tench
Had outlasted every visible stone
Of the monastery that planted them—

Stilled legendary depth:
It was as deep as England. It held
Pike too immense to stir, so immense and old
That past nightfall I dared not cast

But silently cast and fished
With the hair frozen on my head
For what might move, for what eye might move,
The still splashes on the dark pond,

Owls hushing the floating woods
Frail on my ear against the dream
Darkness beneath night's darkness had freed,
That rose slowly towards me, watching.

September 1

STRANGER [*on the way out*]: I see the laughing gulls are still patrolling for snappers.

FISHERMAN: They'll be there until the blues leave for the winter.

STRANGER: From here it looks as if they're skating on the surface, like a lot of busy little water striders. Every bug for himself.

FISHERMAN: Not at all. Those birds are social animals. They'll call to let each other know where bait is near the surface, and it's amazing how quickly they'll

gather from a distance when one of them suddenly announces a heaping plateful.

One afternoon last summer when I was casting for snappers, a laughing gull flew across my line as it was settling toward the water, and the monofilament looped around one of its legs. The bird flopped onto the water and began flapping and screaming. Within ten seconds all the gulls in the area had stopped fishing, and there must soon have been fifty of its concerned fellows wheeling right over it in a tight circle. They seemed ready to attack whatever was harassing their friend. Luckily the loop around the trapped gull's leg was some distance from the lure, so there was no question of its being hooked. I reeled it in very slowly, and the wheeling gulls came toward me over it, and they began swearing at me. I felt as if I were dissolving into some footage of Hitchcock's *The Birds*. I was able to lift the gull up on the deck with the line. It gave me a shriveling dose of eye contact and called me all sorts of gull names. I tried to tell it in a quiet voice that there'd been no intent, the whole thing was an accident. It didn't peck me, nor did the attack helicopters hovering overhead open fire; perhaps by now all the birds sensed that I was trying to help the captive. I gently looped my hands around its deck-dusting wings, then held its body—as lightweight as a candle flame—with one hand, and unlooped the line with the other, and it flew off with a lawsuit in mind, throwing a few last imprecations over its shoulder. Within three seconds the community of compassion was adjourned and the birds were all fishing again, including the one I'd caught.

[*Off the tip of West Chop*]

s : What are the big black birds over there on those rocks?

f : Those rocks, by the way, are the remains of a breakwater that used to be there to shelter the lighthouse keeper's boats, before the light was automated; in some terrible storm, water broke the breakwater's back. Waves —soft water—can be bulldozer blades, moving rocks weighing many tons. Some people think they're qualified to buy and steer a boat by having a driver's license; sooner or later waves will bang sea sense into them, if they don't drown first. Head-on collisions can come every ten seconds on liquid roads. The sea is a scythe.

s : Oh, I realized it on that rough day.

f : The birds you asked about are cormorants. The name's a corruption of the Latin *corvus marinus*: the sea crow. As you can see, they're ten times as big as a crow, but anyway—

s : Look at that one holding its wings out! It's like a noble eagle on a coat of arms. Azure an aquila volant sable, sur bar sinister. Or something like that.

f : Seabirds have an oil gland near the base of the tail, and you'll often see them getting oil on their beaks from back there and spreading it systematically on their feathers, so they'll shed water—"like water off a duck's back," you know. For some reason cormorants are deficient in supply of that oil, so when they've been diving they have to spread their wings, as sailors spread their sails after a drenching, to dry them out.

There's one swimming up ahead. Low in the water, like a loon on a lake, with only its head and neck showing.

s : Oops, it's gone.

F : They tumble forward from a sitting position, like drunks out of chairs, and fish under water. They have short, stubby legs, far back on their bodies, on which they can barely walk. But their big webbed feet give them ocean-liner propellors, which drive them at plenty of knots when they're fishing in rocks and weed; in clear water, over sandbars or a mud bottom, they'll use their wings as well as their feet to swim with.

S : Do they catch blues?

F : They may fish for snappers. They fish a lot on the bottom. Around here, they eat what we caught that day by Nun Three.

S : Not sea robins, I hope, grunting up belly rumbles.

F : I wouldn't be surprised, baby ones. Cormorants sometimes team up and herd their prey. You probably know that the Chinese and Japanese use cormorants for fishing. They loop a lasso on a very long leash around the birds' throats. The cormorants dive and catch fish with their hook-tipped beaks and then can't swallow them because of the chokers. Of course the fishermen reward the cormorants now and then to sweeten the labor. Mediterranean fishermen use remoras—the sucker fish that attach themselves to hosts and ride along, feeding on leftover scraps from the hosts' meals—in a similar way. The remora fishermen, like the Chinese with cormorants, use leashes; the remoras slurp their suckers onto bigger fish and when they've made fast, the fishermen drew them in, loudly thanking the remoras for their help. It seems that remoras, like authors, respond happily to praise from human beings.

s : Folks will go to any lengths to catch fish, won't they?

f : Well, yes. Aristotle says that the balletomane skate can easily be caught by a pair of fishermen, using a net, if one plays music and the other dances on the deck. A Roman writer named Aelian cribbed from another writer named Oppian a formula for catching the fattest of all eels, in the river Eretaenus, wherever that is: You attach several cubits' length of sheep intestine to a long hollow reed; let the free end of the sheep gut, which is tied off, down into the water; when an eel seizes it, blow on the reed; the gut inflates in the eel's mouth; the eel gags and can't let go; you haul it in.

s : If you don't gag first.

f : Oh, look!

s : A storm of birds. What a sight. What's going on?

f : The birds are working over one of those huge swarms of feeding blues I was telling you about. It'll be almost too easy to catch them today. Every cast will hook a blue. I tell you what let's do. Let's catch supper and one or two throw-backs and then just watch the birds. Would that suit you?

s : It would indeed. I've cared more about birds— till lately—than about fishes; land birds, that is. Not that I've ever been an obsessed bird-watcher, but here on the Vineyard I've always put out bird food—especially thistle seed for goldfinches, whose brilliant colors and darting flight give me the same sort of lift Mozart's music does. Birds climbing the sky seem to me a perfect picture of aspiration—"flights of the imagination," we say.

F : Yes, birds do lift our imagination. Richard Wilbur has a haunting poem about how the bluefish, on the other hand, can pull our imagination "back and down . . . to the old darkness," toward the deepest deeps of memory.

Out here, you know, we must think of birds as teachers.

I'm glad there aren't any other boats around this afternoon. So often, inexperienced fishermen will get excited and charge into the heart of the feast and drive the fish down. You have to creep up to the verge of their frenzy, cut the engine, drift, and cast. Let me just get set up. Pencil Popper, I think. Here. Shoot. Don't cast into the cauldron, cast to one edge.

S : You were right. I have one on, on the first cast. This feels bigger than the other ones we've caught.

F : It may well be. Here in Vineyard Sound these slaughters are often the work of roving schools of fish that are bigger than the usual run of the summer in this stretch of water. In fact, in a swarm as big as this there are probably schools of various sizes competing in their greed. I'll gaff it in. There. What a beauty!

S : How much do you think it weighs?

F : I'd say seven or eight pounds. Not a monster, but a nice fish.

S : This is so exciting. May I take another shot?

F : Just let me change the lure.

S : . . . Yes! I have one. . . . This one is logy. It feels heavy, but it doesn't seem to fight.

F : Hold on, I'll get the landing net out from the cuddy. Bring it alongside. Yes, just as I thought, it's a smallish striped bass.

s : What a wizard sight—that banner of bold black lines on an olive and silver field.

f : I have to throw it right back. You said you'd heard that they're a threatened species. That's because their spawning grounds in Chesapeake Bay and in the Hudson have been so fouled by the poisonous effluents of our greed. I never take them ashore, even if I catch them above the legal limit, which in Massachusetts is now thirty inches. Stripers are sometimes mixed in with blues in these mass agitations. Over you go. Good luck! Propagate!

s : With the birds screaming and the water frothing and the gobbets of bait floating, it's like some special circle of hell.

f : Yet you're having a heavenly time, aren't you?

s : I am. And it confirms what I've always thought —that heaven and hell occupy adjoining plots of real estate, with no fence between them.

f : Cast the lure on the right side of the ship, and ye shall find.

s : Oh, and I do. I have one. . . .

f : One of our usual five-pounders. Today we make history: We throw back a smaller fish than we keep.

Are you satisfied that this is too easy? What say we just watch the birds now?

s : That would be wonderful. All that white falling: It's a snowstorm on September first. I guess I see several kinds. What all are they?

f : The largest number are herring gulls and terns. There are a few laughing gulls. It's a bit hard to point out the specific terns here while they're working, but

there should be three species, which are usual here-
abouts—the common, the arctic, and the rarer roseate.

I have something to confess. I adore the race of
terns, and I have a violent prejudice against herring
gulls. Do you think I'm a racist?

s : Do you hate all gulls?

f : I rather like laughing gulls.

s : Then you're not a racist. You're a picker and
chooser.

f : I hope so. Laughing gulls are very helpful; they
point the way to particular fish—to snapper blues, as
you've seen, and, when they wheel in a certain way out
here on Middle Ground in late summer, to bonito, a
delicious fish, but not easy to catch.

s : Why do you hate herring gulls?

f : They're miserable scavengers. They're the ro-
dents of birddom. There are far more of them at the
town dump than out here. They dote on carrion and
gurry from draggers in the harbor. The terns are pure
and devoted fisherbirds; they hover over bait and go
down to it with the grace of Olympic high divers. The
gulls don't know how to dive; they just crash into the
water with horrible bellywhops which scare the bait
away half the time, so they just sit there looking be-
wildered. Then they fly off to follow the *Islander*, hoping
that tourists will toss up peanut-butter Nabs for them
to catch. They chase other birds off, as if they owned
all air space. Ogden Nash got the idea:

> Hark to the whimper of the sea-gull;
> He weeps because he's not an ea-gull.
> Suppose you were, you silly sea-gull,
> Could you explain it to your she-gull?

But I want you to notice something. In the area where the fish are boiling up to the surface—the way I saw them do in that tank at Sandy Hook—nothing, not even a tern, dares to dive. The ravening blues would devour anything, finned or feathered, that they found under the Saran Wrap of the surface. In those spots the birds—do you see?—skim along and without breaking their flight dip their beaks into the water to scoop up fish fragments or surfaced whitebait. The diving for bait and scraps goes on in places from which the school has vacated. I've heard it said that the only species in all the oceans that have taught birds not to land in their picnics are killer whales and bluefish. That puts bluefish in the company of the grimmest Mafia of the sea. Black-and-white killer whales, fifteen to thirty feet long, will attack a far larger whale and tear it to shreds, and sometimes in polar seas they'll swim up under an ice floe and tip it to cause seals, resting on it, to slide off into their meat-grinder jaws.

s : I'm not really sure I can tell terns from gulls. I want to know which birds I'm supposed to like.

f : Be grateful for all of them. Birds know how to fish better than any of us ever will. Terns, herring gulls, laughing gulls, cormorants, ospreys, and gannets have led me to many a supper. Terns happen to be my favorites, but when the herring gulls show up out here, you can hate them all you want, but you can be pretty sure there are big blues down under on the rove.

Terns. They're smaller than the gulls. With their deeply forked tails and dipping, swooping flight, they're sometimes called sea swallows—though of course they're much bigger than those darters over meadows. Grayish

back, white front, little black cap. I love them. They're on their active pinions almost all day long; they rarely loaf on the water, and if they rest at all, it is apt to be on sandbars or flotsam. They have stubby legs and dainty feet, quite unsuitable for strolling or paddling. Most of the ones we see live and breed sociably in very close quarters, as if in a colony of peaceable condominiums, on a sandy patch called Bird Island, across the way in Buzzards Bay. They have amazing vision, which seems to render air and water as transparent as a small boy's lie, and they can hear tern cries from very great distances, as if they were constantly on the phone with each other. They range the length of the Middle Ground rip in twos, threes, and fours, searching, lollygagging along about twenty feet above the water, with their beaks pointing straight down so their photoelectric eyes can be on a steady scan for bait. There is always a leader, who keeps calling to the others. When there is a sighting, high-pitched cries of summons go out like chimes from a steeple, and, miraculously, where there had been two or three and no others as far as the eye could see, there is suddenly a blizzard of divers.

The tern population on the New England coast is declining at an alarming rate. And why? Because herring gulls and greater black-backed gulls—I'll show you a pair of the latter that live on the Vineyard Haven break-water when we go in—those robbers eat tern eggs and chicks. Gulls and terns both breed on sandy offshore islets where skunks, foxes, rats, and other predators can't get at them. As it happens, the gulls, who don't migrate, hatch their broods in the spring, before the terns arrive home from their travels only to find no-

vacancy signs out in the best nesting areas. Then, when the terns do find a place to lay eggs, gulls raid their nests. Gulls have driven terns off the most favorable islands around here—from three places yonder in Buzzards Bay, for instance: Penikese, which used to be a leper colony, deserted now, off Cuttyhunk; the little cluster of the Weepeckets, just a few score yards across from a golden cove on lovely, wild Naushon, where we can anchor *Spray* for picnics with no sight of human habitation anywhere; and Ram Island, off Mattapoisett, on the far side of the bay. A couple of years ago the Fish and Wildlife Service estimated that about two hundred thousand herring and black-backed gulls were nesting from Maine to Long Island, and that in the same reach there were fewer than thirty thousand nesting terns— whose number, furthermore, is falling all the time.

Back in the Gay Nineties both gulls and terns were threatened, as the craze for feathers on ladies' hats took hold. Winged hats became more and more ornate, until ladies could fly along over the sidewalk if they half tried. Some women balanced entire nests of feathers on their heads, in which stuffed birds seemed to be perpetually hatching more hats. Herring gulls brought a bounty of a dollar a piece. Educated marksmen shot them from Longfellow Bridge, close by Harvard College. It has been guessed that the gull and tern counts each fell then to something like twenty thousand.

Later, what with protective laws generated by the Audubon Society, and the offal strewn in harbors by the booming New England fishing industry, and the town dumps swelling like volcanic hills all along the coast, the gull population exploded. The single fishery of New

Bedford handed out dinners to ten thousand gulls. Terns, too, made something of a comeback—until the gulls got at them, capturing island after island along the northeast coast, and extending their selfish breeding range all the way to North Carolina.

One kind of tern we can see diving here right now, the roseate, so-called because of a blush on its breast, is on the verge of being declared an endangered species. In the 1930s, there were thirteen thousand nesting pairs of these birds on the Massachusetts coastline alone; now in all North America there are fewer than four thousand pairs. More than fifteen hundred of these pairs are on little Bird Island, off Sippican Neck, on the other side of Buzzards Bay. That they are there at all is thanks to the passion of a handful of people who have been working devotedly ever since the spring of 1970 to protect the terns on their city of sand from gulls. After a plane crashed on takeoff from Boston's Logan Airport, in October 1960, killing sixty-two passengers, because starlings had been sucked into the turboprop engines, a couple of these very people, with backing from the Massachusetts Audubon Society, the National Science Foundation, and the Fish and Wildlife Service, teamed up with others to experiment with various means of controlling bird populations. They later used a number of those methods on Bird Island. One way was to shoot a very few gulls, which frightened many others away. Gulls are opportunists, however, and they learned fast what a gun was; they would fly away from a man carrying one but not from an unarmed person. For a couple of years, the terns' friends baited gulls' nests with hunks of bread spread with margarine containing a poison, 3-chloro-4-methyl ben-

zanamine hydrochloride, commonly called DRC 1339, which brought a painless, lethargic death caused by kidney failure. But amazingly, gulls that had never eaten the stuff learned to avoid it. The only effective control, in the end, was a systematic breaking of gull eggs, three times every season. This took hard work to do, year after year. There has not been a gull chick on Bird Island since 1969.

s : Isn't that rather rough? Do we have any business going around poisoning seagulls and breaking their eggs? You keep talking about Nature's balance. Should we be in the act at all?

f : The trouble is that we, with our gurry and garbage, were the ones who threw things *out* of balance. And if the outcome were to be left to Nature, under these circumstances, the northeast-coastal species of terns would soon be extinct. I, for one, would hate that. There have been plenty of citizens, to be sure, who've raised a howl about the poisoning of gulls in population-management programs on Bird Island and elsewhere—some concerned about the sanctity of life, some worried that the poisons might somehow affect their own or their children's lives. I guess you could think of the breaking of eggs as birth control. Right-to-Lifers might argue that no one has leave to murder a fertilized gull egg—but on this issue I lean to an older, grimmer code: an eye for an eye, an egg for an egg. Long live the swallow of the sea!

s : You talked about some other birds that have led you to suppers. Are any of them out here now?

f : No. Besides terns, the birds that dive for food are ospreys, kingfishers, gannets, boobies, and pelicans. I've never seen boobies here; they work mainly over

deeper waters. Pelicans, of course, never get this far north. I've seen kingfishers flying around, but they don't seem to feed in Vineyard Sound.

Ospreys, which were nearly wiped out by DDT some years ago, are making a dramatic comeback on the Vineyard. Ten years ago there were only two or three nests on the island; by last summer there were thirty-six breeding pairs here. These huge hawks fish in the evenings near the Vineyard Haven breakwater, and it's a thrilling sight. They hover as if stalled, beating their great fans, fifty feet up, then suddenly fold and fall straight down, and at the last moment before striking the water they reach out their legs below them, toward the prey, talons spread out like the terrible grasping fingers of a scrap-steel crane. They crash into the water, barely submerge, and at once rise with a greater fluster of wings, holding a pogy or young blue in those claws. Twenty feet up they shudder, to shake the water from their feathers, and they rearrange the prey in their feet so it is streamlined for their flight back to the nest.

When I am very, very lucky, I see gannets fishing here. The first sight is of a half dozen of these magnificent birds paddling across the sky with their stiffish wingbeats, pausing to glide now and then, over toward the Elizabeth Islands, about a hundred feet above the water. They are powerful fliers—immature gannets summer on our east coast and winter off West Africa. They are all white, save for the black tips of their pointed wings. Their Brancusi bodies are two and a half feet long, and their wingspreads reach nearly six feet. They are double-ended, with a pointed tail to cut wind drag

at high speeds, and with a beak and head shaped like the nose of a slightly overweight Concorde. They wheel toward Middle Ground shoal, where I'll be trolling. Over the deeper water on the Vineyard side of the shoal, they suddenly tip over from their apparent weightlessness, all at the same time—for they seem to know that if they work together they will confuse the school below and have a better feast than if they fished alone—and, with their wings hunched to half their reach, they plummet from that great height at enormous speed. At the moment of crashing through the water barrier, their wings, enabled by special arrangements of skeleton and muscle, drape directly backwards, enfolding their streamlined bodies, and air sacs under the skin cushion the shock of the impact. They shoot deep down, often to thirty feet. I wonder whether they can swim down there, perhaps using their wings, as shearwaters and diving petrels and cormorants do. Once, fishermen in a dragger pulled in a net that had been set at ninety feet and found a live gannet in it, dizzy, no doubt, with the rapture of the deeps. The sight of the gannets at work takes my breath away. I think about them, diving in a few moments from the airy zone of dreams and limitlessness down, down to a place rich with memory of the sweet fluid and enclosure of the egg.

s : How impressive and moving that must be. Even this, right here, that we've seen—this picture of all the gray and white wings swirling up and down—the skill—always something to swallow in the beaks when the birds break up from the water—all this has been amazing to me. I see it as the reciprocal of the wild savagery

of the blues that you watched that time in the tank in the movie.

F : Yes, that's true. It's as if the skin of the water stood for the equals sign of an equation of survival. . . .

[*Swinging in at the north opening of the break-water*:] Look, that pair circling in to land on the breakwater—those are the greater black-backed gulls I was telling you about.

S : They're huge.

F : Yes, they have wingspans of nearly four feet. They're the hawks of gulldom: they eat small animals and eggs and chicks. It's a pity such crooks are so handsome.

[*In the kitchen*:] Tonight I'm going to use a recipe of Nat Benchley's. First I skin one of the fillets. I'll place it in an oven-proof casserole and pour the juice of a lime over it, scatter a finely minced onion on it, add some pepper, and pour four melted tablespoons of butter on top. We'll leave it to marinate for half an hour while we tell Barbara about the birds. . . .

Now. I'll heat the broiler and put the fish in, close to the flame, for about seven or eight minutes, when it should brown a bit on top. During that time I'll melt two more tablespoons of butter in a saucepan, add the juice of another lime and four ounces of gin. Then I bring this mixture to a boil. At the proper time, I'll pour it over the fish and return it to the broiler. Don't be alarmed: the gin catches fire. I'll baste the fillet once after the flame dies down and cook three minutes and test with a fork. One more minute. . . . Let's go.

S : Hm. Queer combination.

F : Some people love the idea of the gin. And the

gin and the lime do cut the oiliness. However, each to
his own.

 s : You like modern poets. I like Chaucer:

> These cookes, how they stampe and streyne and
> grynde
> And turnen substance into accident.

 f : Are you getting tired of bluefish?

 s : Now you're the one who's sensitive about being
teased.

TROLLING FOR BLUES

by Richard Wilbur

As with the dapper terns, or that sole cloud
Which like a slow-evolving embryo
Moils in the sky, we make of this keen fish
Whom fight and beauty have endeared to us
A mirror of our kind. Setting aside

His unreflectiveness, his flings in air,
The aberration of his flocking swerve
To spawning-grounds a hundred miles at sea,
How clearly, musing to the engine's thrum,
Do we conceive him as he waits below:

Blue in the water's blue, which is the shade
Of thought, and in that scintillating flux
Poised weightless, all attention, yet on edge
To lunge and seize with sure incisiveness,
He is a type of coolest intellect,

Or is so to the mind's blue eye until
He strikes and runs unseen beneath the rip,
Yanking imagination back and down
Past recognition to the unlit deep
Of the glass sponges, of chiasmodon,

Of the old darkness of Devonian dream,
Phase of a meditation not our own,
That long mélée where selves were not, that life
Merciless, painless, sleepless, unaware,
From which, in time, unthinkably we rose.

September 15

FISHERMAN [*as* Spray *reaches the shoal*]: Look at the weed in the water.

STRANGER: Seaweed? I don't think I see it.

FISHERMAN: Those dark ghoul shapes roiling along under water. And the strands of eel grass floating on top.

STRANGER: Ah, yes, I see them now.

FISHERMAN: I brought you out too early today. The tide is still ebbing strongly. That northeast storm we had earlier in the week churned up a horrible harvest, and the current still carries it around. I'm sorry.

Trolling will be messy for a while. We'll have to clear trash off our hooks very often, till the weed temporarily settles to the bottom at slack tide. Besides, the blues don't seem to like trying to concentrate their minds on bait with all sorts of Rorschach blotches flying across their field of vision.

s : You can't blame them. Must be confusing.

F : As confusing as it would be to us to see a lot of fish in a downpour of rain.

s : Who ever heard of fish in the rain?

F : I've seen a sixteenth-century engraving of a "Downpour of Fishes in Scandinavia." And it seems such rainfalls have happened, now and then, when tornadoes over the sea caused waterspouts, which hoisted schools of baitfish into the sky and then dropped them over the land. They have been reported all the way from "De pluvia piscium," in the Deipnosophistae of one Athenaeus, in the third century A.D., to an account in the Northern Whig and Belfast Post, on May 30, 1928, of a fall of fish from the sky during a violent thunderstorm at a village near Comber, County Down.

s : I guess I have to believe you.

F : I'll put Hoochies on, this time. With their single hooks and their skirts of plastic, they are less liable to be fouled by weed than Rebels or Rapalas or other "swimmers" that have two or three sets of exposed treble hooks.

In the two decades since I began fishing here, the weed has multiplied alarmingly. Much of the bay between the Chops used to have a bright sandy bottom; now it's three-quarters dark, mostly with horrid, spongy, tubular green algae, a seaweed called Codium fragile.

That weed is a newcomer to the northeast coast; it was first found in 1957 by a couple of nature-lovers wading off East Marion, on Long Island. It's a greedy monster, which has several nicknames: sea staghorn, spaghetti grass, sputnik weed, oyster thief, and—the one I favor, also used for a kind of coral—dead man's fingers.

s : Oyster thief is an odd name. How come?

f : Oystermen hate it. *Codium* anchors itself in masses on oyster beds. Like all plants, sprays of *Codium* manufacture oxygen. They accumulate it in their sponginess and eventually become so buoyant that they rise like hot-air balloons and lift oysters right out of the beds and carry them away on currents. Around here they pick up sea snails by the hundreds of thousands; north-easters wash great heaps of the weed onto facing beaches, and eventually, when the weed has rotted away, we're left with banks of snail shells a foot deep. The worst of it is that the storms push the weed through the openings to within the breakwater. It rots under water there and releases a stinkbomb gas, which floats into town, like some malicious intestinal message from Neptune, on onshore breezes.

s : How could seaweed just suddenly appear in 1957?

f : Someone brought it here from Japan. I've heard it said that the Japanese eat seaweed, and perhaps some Nipponophile gourmet thought to introduce a new deli-cacy to American palates. The trouble is, this Japanese import is now outgrowing and crowding out other weeds, sea lettuce and rockweed and kelp and the rest.

s : The Honda of the sea. Or is it the Toyota?

F : You're right. This seaweed is part of a larger story. The Japanese are finally winning World War Two.

S : The first day we came out, you said that we are killing the sea. If a seaweed can flourish the way this one has, how can you say that?

F : Maybe killing was not quite the right word—though we have in fact succeeded in killing significant parts of large bodies of water, such as Lake Michigan. Let's say at least that we're meddling dangerously in the affairs of a vast organism—I think of the sea as a living being—about which our knowledge is still very much in a formative stage. The man who was entranced with the thought that *Codium* might taste good with a little teriyaki and so was moved to bring some home from his travels—if there was such a man—was, as things have turned out, a dangerous meddler with the ecosystem of the northeast coast. Reel in your line. I'll wager there's some of his import on your hook. There, do you see? Human beings have caused great havoc in nature by introducing exotic flora and fauna, on whim, into unsuitable settings. For reasons that are unclear to me—perhaps it was his idea of a practical joke—a Vineyarder brought a pair of skunks to our then skunkless island some years ago; the island is host to no natural predators of that animal, and the consequence today is a nearly unbearable plague of skunks. Man, with his retinues of hogs and horses, sheep and goats, dogs and cats, mice and rats, has ravaged many a paradise. When the astronomer Halley, the comet fellow, visited Trinidad, about 1700, he put a few goats ashore; soon, since the goats ate all seedlings, the island's noble forests died out, and

a naked island began to wash down into the sea. Rachel Carson tells how the introduction of rabbits onto the tiny Pacific island of Laysan stripped it of its forest of sandalwood and fanleaf palm, and the Laysan rail, which existed only there, "a charming, gnome-like creature no more than six inches high, with wings that seemed too small (and were never used as wings), and feet that seemed too large, and a voice like distant, tinkling bells," was wiped out on the island. It happened that in 1887 a ship captain had taken some of the rails to Midway, some three hundred miles to the west, and the species might have survived there, but in 1943 a heavy traffic of Navy ships and transports put rats ashore on the island, and a year later the world's last Laysan rail was sighted. W. H. Hudson was right: "The beautiful has vanished and returns not."

We'd better reel in and clear the lures.

You've been able to see, over and over again out here, how all the living things have their places in an interconnected network of existence, and how delicate the balance among the various forms of life is. Man comes charging in with his idea that the ocean is just a convenient big cistern, after all, into which all water eventually runs, including, of course, that in the reservoir tank over the toilet after you've pressed the little lever. My first home in New York City, many years ago, faced on the East River, and when the breeze came off it we were often practically knocked out by the passing of the "honey barges," as they were called, laden with raw sewage being towed out to be dropped—flushed—right into the summer living room of the bluefish, out in the North Atlantic bight. The honey barges no longer ply

that route, but in many places, raw sewage still goes straight into the sea—as, for instance, does that of the whole city of Key West, out through a pipe to a place several hundred yards off one of the few decent swimming beaches on that island. Human wastes seep into the sea from the septic-tank drainage fields in sandy soil all around the shores of our Vineyard, and though the Coast Guard issued regulations a few years ago that toilets on vessels must all be "closed"—incapable, that is, of being flushed directly into the sea—enforcement has been impossible, and many elderly yachts visiting our small harbors still have open heads. (Toilets are called heads on vessels because sailors used to relieve themselves from the nets under the bowsprit, next to the figurehead. Maybe you thought they used the poop deck; not so.) Fecal matter will ferry disease here and there in estuarial waters—raw clams or oysters, anyone?—and it serves in the sea just as it does on land, as fertilizer. *Codium* and other algae thrive excessively on the spate of sewage that we give to the sea. Thus the delicate balance gets tipped.

Our sewers spew out, among other things, dissolutions of Ivory and Dove and Duz, which do no great harm, since soaps are biodegradable. Synthetic detergents, on the other hand, are both lethal and, since they cannot be broken down by bacteria, durable. An experiment at the Sandy Hook lab showed that one pound of detergent took only four days to kill half the fish life they had placed in a tank there, and that it kept its virulent toxicity for three months.

[*Dead man's fingers foul the lures. The two clear them. Fisherman continues*:]

This mischievous trickle into the ocean from bathrooms and kitchens and washing machines is of course nothing to the obscene excretion into our rivers and bays of the toxic wastes of industrial plants. Reports of these make their way onto the evening news broadcasts when, on account of them, human beings from neighboring places come down with leukemia and bone cancer and kidney failure. As to what happens when these poisons run down off the continental shelf into the oceanic abyss—who knows? Who cares about deep-sea life? Newspaper readers may be dimly aware of the threat of these effluents to the striped bass: sportsmen have raised hell about it. Even you, Stranger, who had never been fishing, said on the first day we went out that you'd heard of the trouble stripers are in. Bluefish are spared their particular fate because they go out to sea for sex, rather than into estuaries and rivers like the Chesapeake and Hudson.

But blues don't get off scot-free. The little snappers come in from the spawning grounds to shallows in inlets and at river mouths along the coast, and there they are liable to ingest various industrial chemicals that have settled in bottom sediments and have found their way into the food chain. Polychlorinated biphenyls, commonly called PCBs, which are suspected of causing cancer in human beings, aren't thoroughly degraded in a fish's body or excreted from it; some of them accumulate in the skin and in fatty tissues. Mature blues eat the chubby menhaden, and probably pick up PCBs from them. The federal Food and Drug Administration has recommended that two parts of PCBs per million parts of fish flesh be considered the most that is safe, and one

bluefish in ten caught around here has been found to have that much in it.

s : You've been feeding me all this carcinogenic meat!

f : You and I are not going to die of cancer from eating a few blues. In the first place, since PCBs accumulate over time, the greatest danger comes from the largest fish, and the ones we catch on Middle Ground are relatively young. Besides, most of the PCBs lodge in the fish's skin and in the narrow median strip of dark flesh just under it, and in the flap of fat at the bottom of the belly, all three of which I usually take off when I skin the fillets. To tell the truth, on second thought, I don't always cut away the flap of fat, because it has been found that the kind of fish oil it contains is good for your heart. Cardiologists came on this fact when they wondered why Greenland Eskimos, many of whom eat fish three times a day, seven days a week, have such a low rate of coronary heart disease, and they discovered that fish oils supply fatty acids that can lower cholesterol levels in the blood and reduce the chance of blood clots in one's arteries. Bluefish are notoriously oily. Their fat is practically medicine! I've come to the conclusion that almost everything we eat, these days, is both good for you and bad for you. My philosophy is: enjoy.

s : I guess I'll survive.

f : You will not survive unless you enjoy yourself. [*They clear the lures.*]

Industrial pollution is bad enough, but ever since Hiroshima we have been slowly adding one more taint to the sea—that of nuclear poisons. There's irony in the fact that the technologies of modern naval and air war-

fare—those that emerged during the Second World War in particular—gave mankind its greatest incentive to study the profound peace of the deeps. During the war, oceanographers began to chart the contours of the abyssal bottom; to trace the strange movements of ocean currents, which sometimes mysteriously run in opposite directions, one atop another; and to study the sea floor, with its astonishing resources of sediment and of unexpected life. Those studies have continued, and scientists have begun to pierce our fathomless ignorance about the waters of the world. The policies of naval and military planning, however, are set not by oceanographers and marine biologists, but by men whose primary instincts are for power and the defense of power and the propagation of more power. Just as those who decided to drop the bombs at Hiroshima and Nagasaki gave no thought to their long-term radiation effects on human victims, so those who later made decisions about testing nuclear weapons over the seas, and about flushing wastes from nuclear power plants into them, did so with little or no thought of the subtle long-term effects of their actions on the delicate balances of oceanic life. Oceanographers traced the drift of tritium from the fallout onto the surface of the sea from atmospheric tests in the Pacific in the 1960s, and found it five miles deep in the Eastern Atlantic, off Norway, in the early seventies. Atomic wastes have been spilled or have leached into rivers, and have run into the ocean for further delivery to distant deeps by currents. So far three atomic submarines—two American and one Soviet—have been lost at sea and lie on the bottom of the Atlantic. In the fifties and sixties, radioactive rubbish—so-called low-

level waste matter—was packed into barrels and dumped into the sea, sometimes as close to shore as only twenty miles off. The Atomic Energy Commission conceded that these barrels were liable to be ruptured by deep-water pressures; even if they didn't implode, they would eventually rust out. The Department of Energy, studying various plans for the disposal of highly radioactive nuclear fuel waste under the earth, has also looked into casting these long-lasting embers into solid spikes, ten feet long and a foot in diameter, and dropping them in mid-ocean, on the theory that after falling three miles through water they would be diving fast enough to sink a hundred feet beneath the ocean floor. I've told you about how plant plankton convert minerals in the water to living matter; they also convert active radioisotopes of minerals into "grass," which goes up through the animal food chain and eventually into the stomachs of the men who make decisions about nuclear wastes, among others. Long after the atmospheric tests of nuclear weapons over Bikini, tuna fish swimming within the million square miles of the sea around the atoll were found to harbor in their flesh a radioactivity very much higher than that of the ocean water around them.

After damage has been done, it has sometimes seemed necessary to the decision makers to find out its extent, and they have obliged marine biologists to turn aside from pure research to look into the havoc that hasty actions have wreaked on the environment. For example, the scientists at Sandy Hook had at one point to abandon their patient studies of the natural life of the bluefish in favor of a hurry-up investigation of how much stress from high water temperatures a blue could

withstand—a study which the Atomic Energy Commission hustled them into because hot-water discharges directly into rivers by nuclear power plants were bringing some unforeseen consequences.

s :　How did the blues react to the hot water?

f :　Just a second. Let's check the lures again. The current has let up quite a bit. Maybe we're about due.

In heated water the blues swam faster and faster. (They also did in other experiments with chilled water.) Naturally. They wanted to escape—as they do in the wild, seasonally, migrating as the water cools or warms. And they schooled at night, which they never do under normal circumstances, and which suggested that they felt unusually threatened. When the tests were over, their swimming speed was slower than normal for quite a while, and they were off their feed. Evidently with prolonged exposure to too warm water they would become sickly and be less hunters than hunted.

s :　Yet in spite of all the careless human interventions you've been talking about, blues, you told me one day, are thriving.

f :　They are. Catches of blues by commercial and sports fishermen have never been higher—a hundred and fifty million pounds a year. A third of all the fishes, by weight, caught along the east coast by recreational fishermen in recent years have been blues. New Jersey has estimated that sports fishermen, what with their tackle, their boats, their marinas, their beach buggies, their electronic gear, their charter boats, bring the state half a billion dollars a year—and nearly two-thirds of those Jersey fishermen are after blues. One classic "careless human intervention," as you put it, has been over-

fishing. Two recent gimmicks—acoustic fish finders and enormous nets made of synthetic materials—have enabled man to reduce several worldwide fish stocks, such as those of herring and anchovy, to perilously low levels. The Pacific sardine has been all but wiped out off California. The yellowtail flounder has been overharvested around here. But the supply of blues, despite the annual kill, doesn't seem to be threatened. In fact, when the Mid-Atlantic Marine Fisheries Council, set up under the Magnuson Fishery and Conservation Act of 1976, proposed, in 1985, a management plan for the bluefish, under which both commercial and recreational fishing of the species would be regulated, the National Marine Fisheries Service vetoed the plan, giving the reason, among others, that its cost couldn't be justified, considering the plentitude of blues.

This isn't to say that bluefish won't one day suffer the fate of the anchovy and the herring, if man goes on treating it and the sea with his habitual contempt. The blue is a tough fish, and so far its life-style has spared it hardships like those of the striper. But man is indeed careless; you were right to use that word. And the carelessness has a big reach, which the bluefish won't necessarily outdistance forever. I think it was a mistake not to have a management plan for blues. Who knows when their bounteous stock may spontaneously and disastrously decline, as it has so often in the past?

s : What you've been telling me today is so disheartening. It seems that carelessness is not a strong enough word; that there's something wanton, wicked, and even suicidal in our not using wisely enough what little knowledge we have.

F : Every time I come out here, I feel as if I'm on a voyage—to an unknown destination. Fishing has not all been easy: It has made me face myself, on these voyages, as a member of my careless species—to say nothing of myself as my self. I come out, sometimes, feeling that I am on my way to paradise, to a secret place on the water where I will be totally at home and at peace; then some reminder—a spate of that imported weed, or a dead gull floating, or garbage dumped from a sailboat—fills me with bitterness and disgust and shame. There's a poem by W. H. Auden which uses the idea of a voyage in a way that speaks to what I mean: The poem makes me think about my relationship both with the creatures out here at sea and with my fellow human beings back on land, and suggests that despite the sad reminders here of human carelessness and cruelty, I may be able to get strength from my voyages on the sea to help me deal better with what's left behind, on the land. I guess that's what keeps me coming out.

We human beings may damage the sea, but the sea seems to know how to take its revenge on us. The strange dynamics of the oceans' cycles can upset our own delicate balances. The trading empire of the Hanseatic League around the Baltic fell apart after the supply of herrings in the Skagerrak disappeared. In 1982 and 1983, an erratic shift in weather and current patterns in the Western Pacific caused temperature changes in a current thousands of miles to the east, called by Peruvian fishermen El Niño, The Child; the fisheries off Peru and Ecuador were practically destroyed; there were violent storms on the California coast, which caused devastating beach erosion and mud slides; Tahiti suffered six

typhoons; severe droughts hit Indonesia and Australia; torrential rains caused killing floods along the South American coast; seabirds were threatened on Pacific Islands; and the weather even darkened over northern Europe. There's no telling—

Ha! There's one! Give me your rod and take the one out of the holder. . . .

s : This one has a lot of fight.

f : A tough fish, right?

s : Look! There's another one following it as I reel it in. . . . Did you see it?

f : Yes, I did. That often happens, and I always wonder what it means. Is it a friend, trying to make out what's wrong? A spouse? That's what Bartas—to quote him again—thought in the sixteenth century, writing about fishing for mullet from a beach:

> But for chaste love the Mullet hath no peer,
> For, if the Fisher hath surprised her pheer,
> As mad with woe, to shoare she followeth,
> Prest to consort him both in life and death.

Or was the follower we saw just a hungry blue hoping to be in on the kill of a wounded fish? I'm afraid I'm inclined to think it's probably that.

s : Have a heart. I'm with Bartas.

f [*at the mooring, putting the catch on the trimming board, getting ready to clean it*]: Look here. Do you see those two dark specks on the flank of the fish?

s : Yes, I see them.

f : Those are what we call sea lice. They're among the many parasites that infest blues. We were talking about how tough the bluefish is. It carries around a tre-

mendous burden of parasites and yet, as long as it can eat, it survives, and grows, and swims in good health. I've seen a list of the parasites that attack *Pomatomus saltatrix*—thirty-seven of them, sixteen of which are quite common.

s : Thirty-seven kinds of lice?

f : No. What I called sea lice are little crustaceans that find their nourishment in the protective slime on the scales of their hosts. Some of them are copepods. But there are also many internal parasites: several types of worms—flatworms, roundworms, spiny-headed worms. The blues pick up most of these from their food.

s : And we pick them up when we eat *them*? I've had my last bluefish.

f : No no no. The parasites are all either on the outside, and I scale them off, or they're in their gills, or their intestines, hearts, kidneys, gall bladders, ovaries— their viscera—and we get rid of those when I sliver or gut the fish. They're not in the meat. And anyway, I cook till done.

s : Well, I'm glad to hear that!

f : Actually, the scientists don't know much about what these parasites may do to blues. If a bluefish succumbs to one or more of them, the fish is destroyed within a few minutes by its brothers and sisters. Unlike pathologists working on human ills, marine biologists never have bluefish cadavers to examine. There's very little knowledge, either, about killers other than parasites—viruses, molds, bacteria. We just don't catch badly sick blues. If PCBs can cause cancer in people, they doubtless can in blues, but in two decades of fishing I've only cleaned three fish in which I thought I saw

abnormal flesh that might have been malignant. Healthy blues may kill and devour sick blues and so pick up parasites and other things along the way. The individual fish is a summation of its experiences in its environment. It's a migratory fish, and it swims through zones of danger, picking up trouble as it moves. A scientist at the Marine Biological Laboratory who specializes in parasites told me that some of the pests are beautiful. "You open up the fish," he said, "and find these gorgeous creatures in there."

s : I'll bet! . . . I'm not as hungry as I thought I was a while ago.

f : Wait till you taste what we're having tonight.

[*In the kitchen*:] I'm going to put you to work this evening, Stranger.

s : I'm glad. I hate just standing around.

f : Good. Please wash and peel these five small potatoes, and then cut them into thin slices. Here's a razor-sharp knife. While you're doing that, I'll clean this bunch of leeks and cut them diagonally, to make lots of little ellipses. . . . Finished? Fine. Now I'll put the potatoes and leeks in a saucepan and boil them in as little water as possible until they're about three-quarters done. Meanwhile I'll skin a fillet—see, I'm also taking out the stripe of dark meat but I'm leaving the flap of fat on tonight—good for your heart—and then I coat the meat side with mayonnaise. And melt a couple of tablespoons of butter. . . . Now I take the potatoes and leeks off the stove and make a bed of them in the broiling pan. Drip the butter on them, put the fillets to bed, and broil close to the flame. . . . Come, Barbara, dinner's on.

s : I'm telling myself: This is good for my heart. . . . Hmm. This is plain good.

f : As I said, if you enjoy it, it's good for you. Pliny the Elder listed three hundred and forty-two ways in which fish could be used as remedies. For toothache, rub your teeth with the brains of a dogfish boiled in oil. Soak lint in dolphin fat and set fire to it to cure hysteria. Catch a torpedo-fish when the moon is in Libra, let it hang for three days, bring it into the birthing room, and the mother's delivery will be easy.

s : I'll bear those suggestions in mind.

A VOYAGE

by W. H. Auden

Where does this journey look which the watcher upon
 the quay,
Standing under his evil star, so bitterly envies,
When the mountains swim away with slow calm strokes
And the gulls abandon their vow? Does it still
 promise the Juster Life?

Alone with his heart at last, does the traveller find
In the vague touch of a breeze, the fickle flash of a wave,
Proofs that somewhere exists, really, the Good Place,
Convincing as those that children find in stones
 and holes?

No, he discovers nothing: he does not want to arrive.
His journey is false, his unreal excitement really
 an illness
On a false island where the heart cannot act and
 will not suffer:
He condones the fever; he is weaker than he thought;
 his weakness is real.

But at moments, as when real dolphins with leap and
 panache
Cajole for recognition or, far away, a real island
Gets up to catch his eye, his trance is broken: he
 remembers
Times and places where he was well; he believes in joy.

That, maybe, his fever shall find a cure, the true
 journey an end
Where hearts meet and are really true, and crossed
 this ocean, that parts
Hearts which alter but is the same always, that goes
Everywhere, as truth and falsehood go, but cannot suffer.

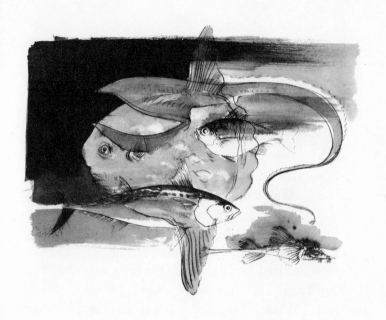

October 10

FISHERMAN: I wanted you to have a chance to fish at sunset, and now it has turned out to be overcast.

STRANGER: The water's like mother-of-pearl.

FISHERMAN: Or more like a silver tray that could use a buffing. October evenings here are either still and hushed like this or wild-eyed with a northeaster. Maybe the cloud cover will help the fishing, anyway.

[*Off the Chop*:]

STRANGER: Look! A shark! Look at that huge fin!

FISHERMAN: That's exactly what I thought, the

first time I saw a fin like that. Let's see if we can get close to it and take a look at what's under water. . . . No, it won't work in this light. Well, you get a good view of the tip of the fin, anyhow. It's rounded, you see, not sharp like a shark's fin; and it isn't cutting the water with a shark's perpetual motion. Just flopping back and forth.

s : It's enormous. What *is* it?

f : Wait a sec, while I put some Rebels on. . . .

The first time I saw one of those fins was in mid-afternoon, one summer's day that was just as calm as this evening is. The water was a sheet of Plexiglas. The sun was veiled by an August haze. The blues were deep and coy. There were five of us aboard. Someone yelled: "Jaws!" Where? Then we all saw it, and everyone chattered. I steered toward the fin. "That has to be a sick shark," another passenger, one of the world's volunteer experts, said. "Sick, the way that fin wobbles." I idled the throttle and glided parallel to the "shark." The tip of the fin went under. We could see a majestic sharp turn toward *Spray*. "It'll capsize us," the expert said. We were all assembled along the starboard cockpit coaming. Now, looking straight down, we could see, as clearly as if we were in an aquarium, a water-colored head about a foot and a half wide, aiming for under the boat. It had what I can only call a cute little face, with big teddy-bear eyes and a tiny thumb-sucker's mouth. It went on and on, for about eight feet, and then there was the great fin we had seen, which must have been three feet tall. I expected thirty feet more of fish to follow and began to think perhaps I'd better give *Spray* the gun, lest the expert's prediction of our being turned turtle might prove

him, for the first time I'd ever run across, to have been right. But there was no more fish. After the fin, nothing. Our eyes couldn't be deceiving us; the water was as clear as that of a mountain brook. The fish just *ended* after the fin.

I couldn't wait to get ashore and make a call to a friend of mine who really is an expert. He laughed and said we'd seen an ocean sunfish, *Mola mola*. How big could it have been? They grew, my friend said, to ten feet long and can weigh six to eight hundred pounds. Yes, right, there was just nothing there, abaft the dorsal fin, nothing but a shriveled-up, scalloped, rudimentary tail. The beast had a three-foot anal fin underneath, matching the one above, and its only means of propulsion was a feeble slow sculling of these two floppy oars. Very chubby—from a side view, deeply oval. It had a leathery skin. In hot weather, he said, full-grown sunfish will float on their sides, lolling, almost as if dead. They have poorly developed skeletons, and one of the weirdest things about this weird giant is that its spinal cord, which in most fishes runs the whole length of the body, is less than an inch long.

s : Are there many of them around here?

F : No. We see one or two or three a summer. Mostly they live out in the open ocean. But sometimes they get caught in currents which carry them here and there, into and out of Vineyard Sound—almost as if they were plankton.

s : In the company of all those microscopic things?

F : Like them, it's a helpless wanderer. We were talking the other day about blues' parasites. The ocean sunfish, being so huge and clumsy and slow, seems espe-

cially subject to various kinds of sea lice on its leathery
skin. There are certain fishes, members of the wrasse
family, one of them called the senorita, that obligingly
hang around these big babies, constantly cleaning them,
vacuuming the water-to-water carpets of their hides.

s : You told me, that first day, when you were en-
couraging me to come out with you, that I'd see won-
ders out here. I was skeptical. You win, Fisherman.
They're here.

F : Oh, Stranger, I'll never get enough of the sea.
I dream of the wonders I'll never be able to lay eyes on.
I wish I owned a bathysphere.

I wish that just once in my life I could see the deep-
sea dragonfish. *Grammatostomias flagellibarba.* It is not
as long as my hand, yet—believe me—it's a monster. At
home in black depths a mile down, dark itself, it flashes
an array of luminous organs on its tapering body—like
a liner seen on the horizon in the night. Its mouth is
big enough to swallow a fellow as big as itself; its needle
fangs are so long that it can never close its lips. But look
(I wish I could) at the whip of its utter strangeness: a
single sinuous tapering barbel, a superwhisker, hung
from its lower jaw, five times as long as its main self,
with bumps toward the end that light up. What for?
Who knows? A lure for its dinners? Or for its lovers?
Or an antenna to send and receive messages to . . .
from . . . ?

I wish I could see a gulper. *Eurypharynx peleca-
noides.* A mile to two miles down, black, two feet long, a
fish, you could say, in the grand oral tradition. Mr.
Mouth. A pelican's gaping suitcase up front. That's
about all. Nothing else but a narrow ribbon attached to

it as a mingy excuse for a body, with a red light bulb on the end. Possessing a mouth that could get around creatures ten times its size, it eats pinpoint deep-sea animal plankton. What will Nature think up next?

I have never seen a sargassum fish. *Histrio histrio.* Back up near the surface. Seaweed metamorphosed into fish, or vice versa, who can tell? It looks like a hunk of its home, which is sargassum weed. Brownish-yellow, mottled with black, lumpy and ragged-finned—in a word, weedy. It seldom swims; it *crawls* around in its other self, using its sargassummy fins as limbs, inching up on its prey and then suddenly opening its mouth and sucking in such a swift rush of water that the victim is swept within.

Nature must have had strange dreams as she made fishes. I wish I could see the ancient lungfish. Do you remember my telling about it—that primitive link between sea creatures and land creatures that John Ciardi wrote about?

I wish I could see the oldest fish of all, the coelacanth.

I wish I could see a male tilapia incubating eggs in its mouth; a European weatherfish wiggling because the barometer is falling; a yellow-nosed wrasse spontaneously changing its sex from female to male because of a temporary shortage of guys; a twenty-foot oarfish, tubular and eelish and writhing, with a red fin atop the whole length of its body, and with a crimson crest on the head as wild as a samurai's rage—a creature to have made mariners think they'd seen a sea serpent.

I wish I could see a spotted trunkfish, a longnose gar, a celestial goldfish, a forceps butterfish, a blackdevil, a John Dory, a lookdown, a lionfish, a hogfish, a

roosterfish, every living kind of angelfish, and all the ravishing beauties on all the reefs in all the tropical seas.

s : I'd like to go with you to see them. Every one of them.

f : And yet, wait a minute, Stranger. When all is said and done, I'll settle for the bluefish. I've seen it. Many times. I'll see it again, many times, I hope. It alone is wonder enough for me. Compared with all the eccentrics of the salt sea and of land-locked lakes, it's so normal. So noble. It has such an elegant hull. It is so wicked and wild when it's hooked. It has such a cruel eye and such passionate jaws. It makes love out in the deep sea, where no peeping-Tom human being will ever pry into its dearest secrets. It's so full of life! And it's true to life; there is nothing fake or soft about it; life is harsh. I've said it before, and I'll say it again: I'm deeply in awe of the bluefish.

s : I'm coming to be. Yes, I am. So let's catch one!

f : The sun's low now. We'll be getting a strike soon.

When I was a child in China, we used to go for the summers to a place beside the sea. I often chased minnows through shallows. My brothers and I fished off Tiger Rocks and sometimes caught puffers, which blew themselves up like holiday balloons to scare us and astonish us. Once a British submarine came and anchored off the shore, and some other boys and I swam out—quite far, it seemed to me—to look it over. While I was treading water out there, in deep soundings, I suddenly saw, close by me, an octopus. It was about two feet (it seems to me now) from crown to fingertips. I

had read about octopuses and submarines, before that, in *The Book of Knowledge* and in *Twenty Thousand Leagues Under the Sea*, and, treading water there, I was able to be both afraid of these two and thrilled by them: man's brutal metal imitation of the fish, and the sea monster, with its pale head, more bald even than my father's; its eight waving arms like those of Siva, the god of destruction; and its two rows of sinister suckers running down each arm, like concave buttons. I remember that while I swam (fast) for shore, I felt wildly exultant —partly because I knew that I had escaped, and a torpedo was not going to sink me and the buttons were not going to be fastened to me; but partly also because it was so wonderful to have had two pictures from printed pages come to life in the sea; and partly, I believe, because I felt (in the proportions of my fear at the time) that the two monsters out there were fairly evenly matched, and if it came to their fighting each other, it would be hard to say whether man's creature or the sea's would win. I'm not telling you this story to psychoanalyze myself but rather to offer you its naive metaphor. Because now, as I drift toward my second boyhood, my amazements at the wonders I see—and don't see—in the sea are tinged with the same mixture of fear and surprise and exultation, and I am haunted by something like the same question about the precarious standoff between the urges of humankind and the needs of the manifold life of the sea.

s : Fish! Fish! . . .

f : Nicely brought in, from beginning to end. . . . Don't look it in the eye.

s : Say, I caught that fish just at sunset—the way I caught one exactly when the clock struck, that morning.

F : Yes, just as the sun fell into the hill at Cutty-hunk, like a coin into a vending machine—out comes the bluefish.

s [*at the mooring*]: I've been thinking about those strange sea creatures you were speaking of. I remember going to dinner one evening in the city at the apartment of some friends, who had set up an elaborate aquarium, ostensibly for one of their children, though I believe their real motive had more to do with interior decora-tion—the brilliantly lit tank made a striking centerpiece for some bookcases. In it, a dozen varieties of tropical fishes lazed back and forth. The father joked ruefully about how expensive some of them had been. I was told their names, but I don't remember any of them. They made a stunning, unforgettable sight. Then one day I heard, maybe a month later, that the small son had for-gotten for several days to clean the filter, and the par-ents hadn't reminded him, and the fishes had all died. I remember that hearing that made me angry—at the parents. I didn't know whether to be sorrier for the boy or for those rare, exquisite fishes.

F : Yes—another version of the standoff, with a sad ending—sad for everyone. There's a poem by James Mer-rill that your story reminds me of; let me see if I can find it after supper.

[*In the kitchen*:] Tonight we're going to try a varia-tion of the basic mayonnaise treatment we used back in June, the second time we fished together—Barbara's

favorite way. I'll make a mayonnaise glaze with mustard built into it.

First I set some water to boil. Then skin the fillet, salt it and pepper it, and squeeze the juice of a lemon on it and let it marinate while I cut the rind of half the lemon into thin strips. I blanch these in boiling water for three minutes, pour them into a colander, freshen them with cold water, and pat them dry in paper towels.

Now. Two egg yolks into the blender, till they're slightly thickened. Then I add a half teaspoon of salt, a pinch of cayenne pepper, a tablespoon of Dijon mustard, and a tablespoon of powdered mustard, and a half teaspoon of dried chervil. Whip up briefly in the blender and then, with it still running, add one cup of olive oil, dribble by dribble. Good. Spread the mustard mayonnaise on the meat side of the fillet, and broil, six or seven inches from the flame, according to the Canadian rule. . . . A minute before the end, I scatter the strips of lemon rind on top, and then finish cooking. . . .

It's ready. Let's try it.

s : Oh, yes. This is wonderful.

f : Yes, a wonder—bluefish.

THE PIER: UNDER PISCES

by James Merrill

The shallows, brighter,
Wetter than water,
Tepidly glitter with the fingerprint-
Obliterating feel of kerosene.

Each piling like a totem
Rises from rock bottom
Straight through the ceiling
Aswirl with suns, clear ones or pale bluegreen,

And beyond! where bubbles burst,
Sphere of their worst dreams,
If dream is what they do,
These floozy fish—

Ceramic-lipped in filmy
Peekaboo blouses,
Fluorescent body
Stockings, hot stripes,

Swayed by the hypnotic ebb and flow
Of supermarket Muzak,
Bolero beat the undertow's
Pebble-filled gourds repeat;

Jailbait consumers of subliminal
Hints dropped from on high
In gobbets none
Eschews as minced kin;

Who, hooked themselves—bamboo diviner
Bent their way
Vigorously nodding
Encouragement—

Are one by one hauled kisswise, oh
Into some blinding hell
Policed by leathery ex-
Justices each

Minding his catch, if catch is what he can,
If mind is what one means—
The torn mouth
Stifled by newsprint, working still. If . . . If . . .

The little scales
Grow stiff. Dusk plugs her dryer in,
Buffs her nails, riffles through magazines,
While far and wide and deep

Rove the great sharkskin-suited criminals
And safe in this lit shrine
A boy sits. He'll be eight.
We've drunk our milk, we've eaten our stringbeans,

But left untasted on the plate
The fish. An eye, a broiled pearl, meeting mine,
I lift his fork . . .
The bite. The tug of fate.

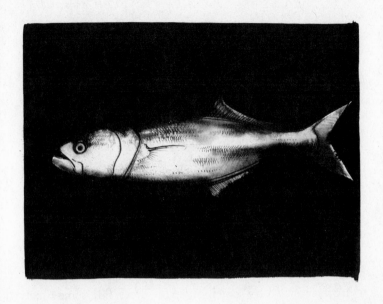

October 28

FISHERMAN: We may be too late.

STRANGER: How could you say that, in a light like this?

FISHERMAN: I didn't mean too late for the sunset. You're right. On a fall evening like this one, when there isn't a feather's weight of wind and there are cotton clouds to soak up the afterglow, we're in for an enchantment, when the sun goes down. Wait and see. No, I mean a much worst tardiness.

STRANGER: What are you saying?

FISHERMAN: I caught easily out on the shoal

on Monday. Tuesday I had to work like the dickens. Then I skipped a day. On Thursday I was skunked. They were not there. I think they've left Middle Ground —for good.

s : The season's over?

f : Oh, Stranger, this is a bad time of year. To me, the drifting away of the bluefish is the falling of leaves— the shoal becoming as bare and sapless as a stripped branch—another harvesttime marked off, one more winter of a frigid and hostile sea to come, too soon. What I hate most is when *Spray* finally has to be hauled, and she lies in her cradle in the railway in the shed, out of her element, almost like a blue in the fish box.

But I don't want to give up yet. I won't believe that it's over. We'll try something today. Each fall, some time early in October, a school of big blues moors itself awhile inside the tip of the Chop—fish probably from east of here, from off Monomoy or Tuckernuck or Muskeget or one of the shoals like Horseshoe, blues that have been triggered to migrate and have stopped off for a couple of weeks to have a nice fat feast in here between the Chops.

s : A feast? On what?

f : On a calm day like this you can see for yourself. Do you see those wide rings of ripples on the water? Three or four of them, scattered around? Dark wheels going nowhere?

s : Yes. Yes, I see them.

f : Those are the tracks made by the dorsal fins of big schools of pogies—menhaden—which have the habit of going round and round in tight circles like that, the myriad triangular spiny knives that they carry on their

backs cutting through the satin surface of the bay. Look, now there's a ring close by. Can you make out the hundreds of fins? In here at this time of year we don't often see a mass slaughter by hordes of blues, with birds working over it; rather, big free-lance blues—and also biggish solitary weakfish, or sea trout—lurk under the schools and occasionally dart in for a kill.

s : And you fish by the rings?

f : The meat fisherman does. He'll catch a menhaden for a lure; he'll cast a bare treble hook into a rotating school, bring the line in with sudden jerks, and in that way snag a chance pogy, about eight inches long, in the flank. Then he'll bait his larger hook with the menhaden and let it down, wounded but still swimming, near the wheel of a school, and often a raiding bluefish or sea trout will take such an easy offering.

Since I'm not after quantity, I prefer a different kind of fishing. The blues are also feeding on our friends the snappers and tailors, a few of which, at least, are probably still here in their grand hotel, off the meadows and the two pilings, getting up their strength for their own long trip south. By now the snappers make good eating, for either people or blues—nine or ten inches long.

All right, here we are, on the hotel roof. Now, we run out from here eastward, directly toward Nun Three, about a hundred yards, about a third of the way to the buoy. . . .

We'll use the beach rod today, so we can get really long casts, and I'll put on the yellow Stan Gibbs plug that swims like a hurt pogy and gives off the glowing flashes one can see as the menhaden turn and shimmer in their merry-go-round. Here. Take some shots. These

big ones aren't easy to catch this way. It may take quite a few tries.

s [*casting*]: Where do the blues go?

F : The only thing I can say for sure is that most of them go toward warmth in the winter. Wouldn't you, if you lived in the water? I like to, and I live on land. Migration is one more of the marvels and mysteries of this wonderful animal. For many years, investigators have been catching blues, clipping marked tags to them, releasing them, and waiting for returns on the tags when the fish are recaught somewhere else. There has been a fair amount of evidence about their movements, but some big uncertainties remain.

Prodigies of travel have been reported. In January 1939 a fish that had been tagged off New York was recaptured off Cuba. In 1969 a blue that had been tagged in the New York bight was recovered in the Gulf of Mexico. I know of at least one scientist who thinks some of our blues may winter off the Azores or West Africa; he thinks we ought to be using tags with French and Spanish on them, as well as English.

There's still a lot of guesswork involved, but the pattern seems to be something like this: In the fall—around here, in late October and early November—the younger blues, snappers and yearlings and perhaps two- and three-year-olds, move southward along the coast, where the water stays somewhat warmer than over the deeps. The bigger and hardier blues stay around a bit longer and then head out to sea and work their way to warmer water down along the edge of the continental shelf. Blues show up offshore along the southern Florida coast in midwinter, and by March anglers make good

catches along the beaches. Then toward the end of March and in April the parade of younger blues moves northward again along the coast, past Georgia and the Carolinas, to arrive off Virginia and Delaware in late April. Some find their home grounds there, and stay. Others move on, and reach New Jersey and New York in May. The bigger blues, swimming deep, have again paralleled the inshore procession, and commercial fishermen take some of them off Rhode Island and Massachusetts by late May. My logs show the smaller blues arriving in Vineyard Sound, most years, in the first week in June. There are variations, of course, caused by unusually cold or warm stretches of weather in the spring.

Tag recoveries have given some idea of the blues' rates of travel. Depending on their size and the weather and perhaps the food they find along the way, they swim between seven and thirty miles a day. One tagged fish had traveled nine hundred ninety miles from Florida to New Jersey in seventy-seven days.

There's speculation that some blues have gradually become cold resistant and winter over, far offshore, without going south—something like the cardinal, which used to migrate to warm zones but now can be seen all through the winter in many parts of New England. A few blues are caught off to the south of the Vineyard as late as mid-November, and deep trawls have occasionally taken bluefish over the Hudson canyon in midwinter. But most of the blues clear out of these coastal waters at about this time of year.

s : You spoke of the blues that come in here for a final feast as having been "triggered" for migration. What pulls the trigger?

F : Light and heat; darkness and cold. Do you re-
member, the day when we were talking about clocks, my
speaking of how the arrival and departure of daylight
set the diurnal rhythms of the blue's swimming and
feeding and resting? The varying length of time between
dawn and dusk controls its larger, seasonal rhythms, too.
Here is one of the many things that amazes me about
this fish. When daylight pours down into the water for
almost exactly twelve hours off the south Florida coast,
not much longer, not much less, some hormonal bell
rings in the bluefish, telling it to get going. What it
cares about, in taking the road, is the temperature of
the water in which it is to spend the summer months.
But the water temperature hasn't changed much yet off
Florida; it is the particular span of light, coded in the
fish's brain, that tells it the time has come to move. For
the trigger of the move away from here, the coded day-
span is shorter than twelve hours: about eleven and a
quarter.

The fish has free nerves in its skin that act as sensors
of heat and cold. As it moves northward, the feel of the
seaway through which it drives its stubborn, undulant
hull obviously begins to influence its rate of travel. The
temperature of the flesh of a fish exactly corresponds to
the temperature of the water in which it swims. There
couldn't be any such thing as a thermometer for all
fishes, with a gradient marked "normal." There are
nearly seventy-five Fahrenheit degrees of difference be-
tween the body temperature of a species of fish at the
equator and that of another in arctic waters. The typical
bluefish functions most at ease when its temperature—
and that of its bath—is between 64° and 68°, though it

can tolerate a considerably wider range. When the water cools to below 53° or warms to more than 85°, it shows signs of stress; its patterns of daily life go out of whack, and it swims faster and faster, trying to make its way to a warmer or cooler tub. It arrives on Middle Ground in the spring when the water temperature here reaches 54° to 59°—cooler than it really likes, but some deep folk dream apparently tells it that the Sound will soon warm up, to its liking, and it stays. In the fall, it is triggered to move by the shortened days when the water falls to 55° to 59°.

s : How does it know where it's going?

f : Ah, there you're getting to the darkest and, to me, the most beautiful mysteries—those of orientation and navigation. How do migratory birds and fish know where they are? How do they know where they want to go? Once a seabird called the Manx shearwater was taken all the way to Venice from a breeding colony on Skokholm Island, off Wales. When released, it circled briefly as if looking down for a quick study of a chart of reality, and then it struck out on the exact compass bearing for home, which it reached, having flown overland across the whole of Europe, in fourteen days. I have installed a tall pole with crossbeams on top for ospreys to nest in, on the sand flats in front of my house. If a pair settle there and build their nest, they will travel to Brazil for the winter, and the following spring they'll fly back, three thousand miles, to this very same nest.

Blues apparently don't home in quite such a pinpoint way as the shearwater and the osprey do—or as the salmon does, which returns from world travels to its natal stream; but tag reports have shown that many blues

do come back to the same general area year after year. I like to imagine that there's a tribe of Vineyard blues. How do they find their little island? How will they know, when they leave here this week, where to head for the vast baths of warm water to the south? The smaller fish, remember, go largely *west* at first, along the shore. We have some slender clues to the ways in which they plot their courses, but here again we have to guess.

We know that some fishes navigate by the sun—and probably the bluefish mainly steers to its goal by this means. These fishes quite literally have a sextant in their heads. They can "shoot" the sun and, with the help of a chronometer in the brain, which is constantly adjusted by the varying spans from dawn to dusk, can factor the azimuth of the sun with the time of day and know where they are and on what bearing they must travel onward. Experimenters once captured white bass, *Roccus chrysops*, and, having taken them in various directions from their spawning grounds, released them with nylon threads and little floats attached to them. On sunny days, the floats were towed straight for home; on cloudy days the fish confusedly zigged and zagged.

s : It's all very well to have a course, but toward what destination? How does the blue know what to aim for?

f : We have to guess that some folk memory, programmed over the centuries into the blue's neural computer, must tell the snapper to go west and then south in the fall, come north and then east in the spring.

s : Excuse the interruption, but should we just keep on casting here?

F : Yes, this is our best bet. We're on the cusp of the season. Either we'll catch or we won't catch.

S : Please go on.

F : Besides using solar navigation, some birds and some fishes actually carry compasses. The mineral magnetite is found in their nervous systems, and sometimes it is concentrated in one area of the brain. Experiments with certain land birds have shown that they can figure out compass directions and north–south distances from variations in the inclination of the earth's magnetic field in relation to a horizontal plane. Birds that can steer with their compasses sometimes lose their way in magnetic storms that are caused by eruptions on the sun, and they can be thrown off course in areas with extreme local magnetic deviations. But over long journeys, they seem to be able to adjust for such errors. Magnetite has been found in the brain of the bluefin tuna, which steers itself over great distances in the Pacific, ranging with precision from one feeding ground to another. So far no one has isolated magnetite in the bluefish, but neither has anyone ruled out its harboring small quantities of it, or of some other mineral that is responsive to magnetic influences.

Among the aids the salmon relies on, in homing to its birthplace, is its sense of smell. Can it be that our Vineyard tribe of bluefish—if there is such a thing— having made their nostalgic way northeastward in the spring, taking fixes on the sun, maybe partly conned by compass, guided, too, by responses to the lengthening of days and by changing temperatures of the water, and influenced by the movements of bait, at last sniff out

certain delicate liquid aromas, emanating from our Menemsha Pond, Lake Tashmoo, Sengekontacket Pond, Lagoon Pond, Cape Poge Bay, and, in the years when there is a cut in the barrier beach, Katama Bay? That good old Vineyard sea scent—the wonderful musty-sweet smell of their summer house?

s : You once spoke of something about the blue—I think it was the lateral line—as being a high-tech piece of equipment. I suppose they must have small brains, but what gifts are built into them!

f : Survival gear, refined over millions of years. Sacred gifts, Stranger.

s : A fish has taken the lure! Oh my God, this is something else. I haven't felt anything like this, ever.

f : Don't rush it. Let it run when it wants.

s : "Let"! It runs whether I want it to or not. . . . This fish wants to live. . . . I'm tired. . . .

f : Keep it coming. . . . I'll gaff it in. . . . There! Isn't that handsome?

s : How big would you say it is?

f : Twelve pounds, maybe.

s : You won't like this, Fisherman, but I think I understand now why anglers like to pull in big ones. That was a battle; getting that fish to the boat was an accomplishment. In the face of all my scruples, that was fun! And yet—I don't know—after all that you've told me about these magnificent creatures—I remember the Elizabeth Bishop poem—the big old veteran with five hooks in its mouth—part of me feels sad to think that I'm killing a survivor of so many years of trials. A hero.

f : Oh, every time I haul in a blue, big or little, I have so many strange mixed feelings. I'm moved by the

fury of the fish, I'm astonished every time by its pride, by the energy of the negation in its leaps, by its thrashing refusal—to the very limit of its endurance in the poisonous air—to accept my views of its place, and my place, in the food chain: in the universe. I can confess to you, now, that every time I catch a bluefish, I have doubts about what I'm up to. It's not that I feel guilty; someone has to harvest food. I love fishing. It *is* fun. It's also a craft, and I want to be good at it. I'm at home on the water. As you've seen, every fishing trip brings amazements. But I live in a different era from Izaak Walton's. When I pull in a blue I feel as if I'm caught in a process in which human values have lost their bite. I'm caught on an invisible line, and I'm being pulled toward being a fish. You instinctively jumped at the image, early, Stranger—the fisherman on the wrong end of the line. I can joke about a fisherman getting fishy, but I don't like it. I am in awe of the bluefish, but I don't want to become an animated chopping machine. I've said often that fishing is complicated. There are wonders and horrors out here, and sometimes it's hard to say which is which; food chains are serenely fitting and gruesomely cruel; life *is* harsh. The James Merrill poem I showed you the other evening speaks (in another language, as it were) to these doubts of mine.

s : Yes, I noticed that the child in the poem couldn't face the eye of the cooked fish. The blue's eye shocked me that very first day.

f : It forgives nothing. Ah, Stranger, it's complicated, isn't it?

[*In the bay, on the way in*:] Have you ever seen anything like that sheen on the water?

s : Merrill caught the look of it in that poem—brought the sense of touch to what's seen—strange—with the idea of dipping your finger in kerosene. No, I've never seen—or touched—anything like this. It's as if a rainbow had been dissolved onto the surface.

f : These calm, final fall evenings are cruel. This may be the last hour of the last day of one more season of my life.

s : I never imagined I'd come to hate a thought like that one—about a fishing season, of all things.

f [in the kitchen]: Away with doubts and regrets, Stranger! Another dinner to enjoy. I'm going to cook the fish tonight with what seems to me the most reliably pleasing recipe of all—and so simple to prepare.

First I'll skin the fillet, taking away all the dark meat and cutting off the flap of fat, since this is an oldish fish. I'll use the food processor, to mince fine first an onion and then about an inch and a half of fresh peeled ginger root. Over a low fire I sauté the onion in butter until it begins to turn soft and transparent, and then I add the ginger and cook slowly for three or four more minutes. Now I make some fresh mayonnaise and mix four heaping teaspoons of it (these proportions are generous because this is a pretty big fillet) with a teaspoon of soy sauce and half the onion and ginger. I coat the meat side of the fillet. I spread the rest of the onion and ginger in a buttered and heated broiling pan, over an area just big enough for the fillet, put the fish on it, and broil, five inches from the flame. This big fillet will take sixteen or seventeen minutes. . . .

All set! Close your eyes, Barbara and Stranger. Imag-

ine that this dish is being brought to the table by servants crowned with flowers, to the music of flutes.

s : Oh, Fisherman, you were right. This is *very* pleasing. . . . Did I hear you speak of horrors out there today?

F : Horrors? I forget. What horrors?

s : Eating fresh-caught fish at a round table with friends—what could be better?

F : Would you agree that "this dish of meat is too good for any but Anglers or honest men"?

s : Oh yes, I would! But what is the "or" doing in that sentence?

PERMISSIONS ACKNOWLEDGMENTS

Grateful acknowledgment is made to the following for permission to reprint previously published material:

Atheneum Publishers, Inc.: "The Pier: Under Pisces," from *Late Settings*, by James Merrill. Copyright © 1985 by James Merrill. Originally published in *The New Yorker*. Reprinted by permission of Atheneum Publishers, Inc.

Basil Blackwell Limited: Excerpt from "The Ballad of the Valiger," from *Larval Forms and Other Zoological Verses*, by Walter Garstang.

Doubleday & Company, Inc.: Excerpt from *The Odyssey*, by Homer, translated by Robert Fitzgerald. Copyright © 1961 by Robert Fitzgerald. Reprinted by permission of Doubleday & Company, Inc.

Farrar, Straus & Giroux, Inc.: "The Fish," from *Complete Poems*, by Elizabeth Bishop. Copyright 1940, © 1983 by Alice Helen Methfessel. "The Drunken Fisherman," from *Selected Poems*, by Robert Lowell. Copyright 1944, 1946, 1947, 1950, 1951, © 1956, 1959, 1960, 1961, 1962, 1963, 1964, 1965, 1966, 1967, 1968, 1969, 1970, 1973, 1976 by Robert Lowell. Copyright renewed 1972, 1974, 1975 by Robert Lowell. Reprinted by permission of Farrar, Straus & Giroux, Inc.

Harper & Row, Publishers, Inc., and Faber and Faber Limited: "Pike," by Ted Hughes. Originally published in the United States in *New Selected Poems* by Ted Hughes and in Great Britain in *Lupercal* by Ted Hughes. Copyright © 1959 by Ted Hughes. Reprinted by permission of the publishers.

John Hersey was born in Tientsin, China, in 1914 and lived there until 1925, when his family returned to the United States. He studied at Yale and Cambridge, served for a time as Sinclair Lewis's secretary, and then worked several years as a journalist. Since 1947 he has devoted his time mainly to fiction. He has won the Pulitzer Prize, taught for two decades at Yale, and is a past president of the Authors League of America and past Chancellor of the American Academy of Arts and Letters. For more than twenty years he has spent his summers in Vineyard Haven, Massachusetts, where he has fished for blues and studied the life of the sea. In the winter he migrates to Key West, Florida. He is married and has five children and three grandchildren.